Photographers

Compiled by C. S. Middleton

To Harold White in
acknowledgement of his generous
encouragement through the years.

WENSUM BOOKS (NORWICH) LTD
33 ORFORD PLACE
NORWICH NR1 3QA

First Published April 1978
ISBN 0 903619 23 7

Printed by Euromedia Print Limited, Norwich
Bound by Richard Clay (The Chaucer Press) Limited, Bungay

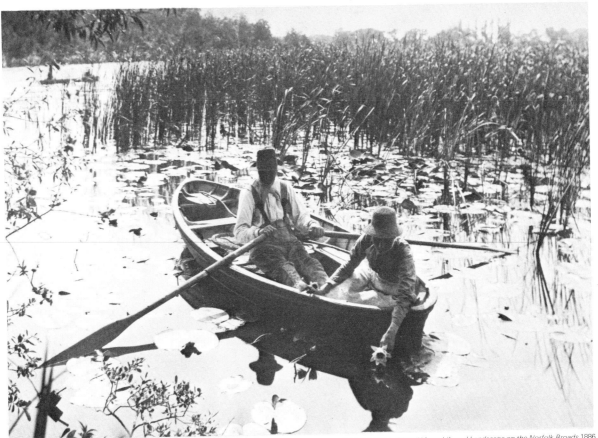

Gathering Water-Lilies

P. H. Emerson Plate IX from *Life and Landscape on the Norfolk Broads* 1886

THE BROADLAND PHOTOGRAPHERS

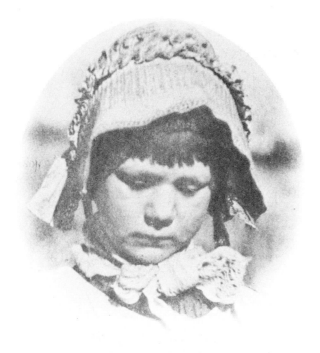

A Norfolk Flower by P. H. Emerson.
Plate XXXII from *Pictures of East Anglian Life* 1888

Acknowledgements

The book is based on an idea originally conceived by Alan Dean.

Photographs The photographs of Peter Henry Emerson and George Christopher Davies are from the Collection of C. S. Middleton. The photographs of John Payne Jennings come from the Colman Collection in the Colman and Rye Libraries, Norwich City Library, and were copied from the originals by C. S. Middleton. The photographs in the introduction all come from Norwich City Library, with the exception of the carte-de-visite by J. Payne Jennings which was kindly loaned by David Cory.

Captions The material for the captions was selected by Michael Shaw exclusively from the writings of the photographers themselves or their collaborators.

Introduction The biographies and general introduction were research by Michael Shaw with the invaluable assistance of Frank Sayer, Bill Beattie, and John Marshall of the Local History Section, Norwich City Library, and R. W. Moon of Ashstead and Mr Hayward of the Leatherhead Local History Society.

Introduction

The three men whose photographs comprise this volume were as markedly different as it was possible for Victorian gentlemen to be. None of them came from Norfolk and their reasons for coming were as diverse as pleasure, profit, and art can be. Quite possibly they never met and yet an affable solicitor, an enigmatic and taciturn photographer, and an arrogant, wealthy genius have left a record of East Anglian life between 1880 and 1890, so complete in both pictures and words that it is sometimes difficult to believe there was no collusion.

Pleasure in Broadland

George Christopher Davies came to Norfolk in 1871 when he was twenty-two years old. He was a Shropshire lad by birth and came from a good family. He had recently passed his law exams and come to Norwich to serve part of his articles. During his short stay he formed several lifelong attachments. He met and married the daughter of Robert Cooper, a fellow solicitor, and he made the first of many visits to the Broads where he discovered his lifetime loves of sailing, fishing, and natural history.

In 1876, aged twenty-seven, and practising in Newcastle, he poured his new-found enthusiasm into an adventure story for boys set in the Norfolk Broads entitled *The Swan and her crew*. Its heroes Frank, Jimmy, and Dick, design and build their own craft *The Swan* - in fact the first chapter describes Frank choosing the tree. The book had enormous impact, filled as it was with continuous rustic adventure and inexhaustible discoveries of birds' eggs, fish, animals, and plants.

Arthur Patterson, the famous local naturalist 'John Knowlittle', recalls the effect the book had on him.

> I remember well how we youths who followed the Breydon men, like Spaniels, went excited over a copy of *The Swan and her crew* which the Yarmouth bird-stuffer lent us to read, in rotation. That little book took hold of me more than ever did Robinson Crusoe, my patron saint.

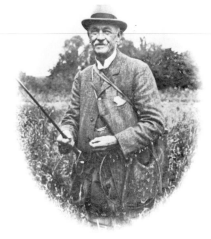

Viola Grimes

George Christopher Davies trout fishing on the River Nar.

The book created a demand and interest in the Broads which may have surprised even its author. In 1883 he published his major work, *Norfolk Broads and Rivers*, a compelling and comprehensive description of the life and landscape of the Broads into which he distilled all the natural history, folklore, local characters, and country crafts he had discovered. It also contained twelve photographs:

> Part of the equipment of the yacht is a photographic camera, and the illustrations in this book are printed on copper plates direct from the negatives and etched by a process, worked by Mesrs T. & R. Annan [of Glasgow].

The book seems to have been another remarkable success for the second edition of 1884 has steel engravings instead of photographs, suggesting a considerably larger run than the first, for Annan's copper autogravures were restricted to about 3,000 impressions. In 1885 the local firm of Jarrolds published twenty-four of his photographs in a portfolio entitled *The Scenery of the Broads and Rivers of Norfolk and Suffolk*, which was quickly followed by a second collection bearing the same title. These cruises on Norfolk and Suffolk waterways were made during visits to his wife's parents for

throughout this entire period of successful writing **and photographing** Davies lived away from Norfolk.

Early trips were made in the *Coya*.

The *Coya* was a 4-ton yacht, especially adapted for single-handed sailing. She was 20 feet overall, by 7 feet 9 inches beam, with a large centre-board. She drew only 2 feet of water with the board up. Her cabin had 3 feet 8 inches headroom. It does not admit of a standing position. When you want to stand, which at certain stages of dressing is advisable, you must go into the stern sheets or well, where, when at anchor, a tent is made by means of an awning over the boom. The mate [Davies's name for any friend, he always referred to himself as the Skipper] called the cabin a 'respectable dog-kennel' but by the time experience had taught him where the knocks came in when you incautiously moved about, he had come to regard it as a spacious apartment.

The Broads he found were little short of Paradise. Their water was crystal clear and Davies frequently alludes to watching shoals of fish basking or feeding among the water-lilies and reeds. Bream would come and nibble at his fingers, tench could be picked out of the water. The great angling obsession, however, was the pike. This carnivorous fish is exceptionally good to eat and formed the staple diet on many of his trips.

Inns were few and far between and shops unheard of. The explorers slept in hammocks in the cramped cabin and fished for their suppers. There were, of course, no auxiliary motors so all transport was dependent on the wind or the quant—a long pole used for pushing the boat along.

Davies and his companions obviously greatly enjoyed these outings indulging in that propensity of all men to revert to being small boys at the slightest opportunity.

I have been wondering what you looked like. I have it now. You are precisely like a travelling acrobat with your indiarubber shoes, white trousers too tight and too short for you, blue jersey, red cap, chin like an aged broom.

There was much light-hearted falling in the water. Usually when the quant became stuck in the mud or unsuspecting friends fell into concealed dykes. Mud had many of the same comic qualities with the added advantage of people occasionally disappearing up to their armpits and having to be rescued.

Nor were the expeditions restricted to the summer months:

Sometimes there was a low growl, then a sharp vicious snarl, then a report like a gun, and then like a crash of thunder. The ice was 'on the work', probably through the influence of the tide affecting the level of the water. The sounds ceased at five o'clock and then the cold became almost unbearable. During an uneasy slumber, a knee had got uncovered and was aching with cold. The blanket under our chin was covered with rime, and there were icicles on one's moustaches. The fires were out, and it was a weary, sleepless wait until the first peep of day gave us permission to get up and go out with the gun.

Even in the summer, however, conditions were fairly spartan with no toilet facilities and, of course, no water.

We have many times drank the water of the Broads, but however limpid it looks, it tastes like rain-water and we cannot forget the mud at the bottom, which, if stirred up in shallow places by the boat's keel often emits a most disagreeable smell.

Norfolk beer was termed 'sweet' and was probably not unlike the 'mild' of today. Most contemporary writers hated it.

Beer is out of the question, claret is rasping, lemonade does not quench the thirst;

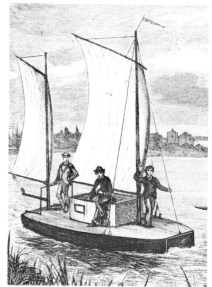

The Swan. *An illustration from Davies's first book* The Swan and her crew *published in 1876.*

One of the fine natural history engravings —'Common Snipe' which illustrated The Swan *and her crew.*

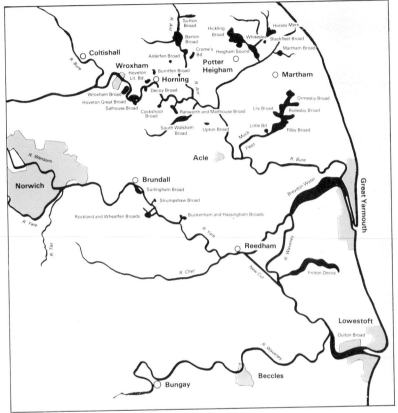

Davies and his contemporaries were uncertain about the origin of the Broads and frequently refer to them as lagoons. Indeed their precise origin remained unclear until the 1950s.

At the end of the Great Ice Age the melting ice-cap raised the sea-level flooding the coastline and creating large estuaries over the lower reaches of the Waveney, Bure, and Yare. As the water subsided it left marsh and large quantities of high-quality peat formed from decaying alder trees. During the thirteenth century those peat-beds became the centre of a large industry for when cut and dried peat forms a slow-burning and valuable fuel.

The diggings were extensive and covered a far larger area than the 5,000 acres the Broads occupy today. As the water-level fell so the surrounding marshland shrank as it dried out. Without drainage the diggings became prone to flooding. By the early fourteenth century they became unworkable. Subsequently the reeds and bullrushes which die off annually on the river margins decayed and created the mud which now covers the shallow bottom of all the Broads. In time the reeds, through generations of annual decay and growth, have raised themselves above water-level and so encroach continually upon the open water.

lime-juice and water, milk and water and weak cold tea are the best. We kept our liquids icy cold by the simple expedient of wrapping the bottles or jugs in cold towels, and exposing them to the sun. The hotter the sun and the quicker the evaporation, the colder was the liquid.

Tinned food was available but not much used. One suspects its use was looked upon as cheating. Fresh meat was occasionally purchased.

We rowed in the Jolly [a towed rowing boat] to Irstead, but we found there was neither shop nor post-office in the village. We went to Barton, where, after a long walk, we found a person who sold us some fresh pork, but there was no post-office, and the people did not know where there was one, but there might be one at Neatishead, three miles away. So we tipped a boy to go in search of a post-office. As our letters reached their destination, he ultimately found one.

In 1889 when he was forty, Davies returned to Norwich and became a partner with his father-in-law in the firm of Cooper and Davies. By this time the Broads were becoming popular and Jarrolds commissioned him to write his best-seller: *A Handbook to the Rivers and Broads of Norfolk and Suffolk*. This book eventually ran to over fifty editions. A much slighter volume than *Norfolk Broads and Rivers* it contains useful information rather than compelling description. He was no longer singing the praises of an unknown

Paradise but preaching to the converted. The book begins with a short lecture on boating etiquette and contains the following sound advice perhaps learned from experience: 'Remember that sound travels a long way on the water, and do not criticise the people you may encounter with too loud a voice.'

In 1906 he became Clerk to Norfolk County Council and the proud and deserving owner of Burnt Fen Broad where he spent his leisure hours in old age.

He was dubbed 'The man who found the Broads' and, in later life, was sometimes criticized for having helped bring about the destruction of the waterways he loved so much. Certainly in his lifetime he saw the growth of 'a hire fleet of 160 yachts, many of them with one or two attendants, a score of pleasure wherries, and a dozen or so motor cruisers'. Today there are some 2,000 hire craft on the Broads. Arthur Patterson came to his defence avowing that he had given 'more pleasure to more people than was ever obtained by the fixing of the North Pole'.

He died in 1922 and the local historian Walter Rye and his other Council colleagues were unanimous in finding him 'an honourable, reliable, knowledgeable, approachable and kind friend'.

Profit in Broadland

Although Davies may have 'found' the Broads there is no doubt that another body was far more assiduously promoting them as a holiday resort than ever he did, and that body was the Great Eastern Railway Company.

The first railway in Norfolk was built by its inventor Robert Stephenson, with the help of his son, in 1844. It ran from Norwich to Great Yarmouth and had stations at Berney Arms, Reedham, Cantley, Buckenham, and Brundall, all of which lie, of course, on the Yare. The line from Whitlingham to North Walsham, with a station at Wroxham on the Bure, was built in 1874. In 1883, the year that Davies published *Norfolk Broads and Rivers*, the G.E.R. built an alternative route from Breydon Junction to Acle, which rejoined the original track at Brundall.

Still further interest was created in Norfolk as a holiday resort by Clement Scott's 'discovery' of the rustic pleasures of the North Norfolk coast in *Poppyland*, published by Jarrolds in 1885. In the back of this book can be found an advertisement for the G.E.R. and it marked the beginning of a vigorous campaign by the Company to foster and exploit interest in East Anglia. To this end it commissioned John Payne Jennings to come to Norfolk to photograph the Broads. These photographs decorated the compartments of its carriages for many years. Not to be left out, in 1890 Jarrolds published a small edition of these photographs - each individually pasted in by hand - entitled *Photographs of Norfolk Broads and Rivers*.

In all his publications Jennings remains absolutely mute. So far as is known he never wrote a single word. Anything known of him is chance discovery. His family probably came from Market Harborough in Leicestershire.

In the Directories for 1875 and 1877 a Susan Jennings is listed as the owner of 'Photographic Rooms'. A carte-de-visite, the standard size of studio portrait of the time, mounted on card, survives with Jennings's name printed on the back. This was almost certainly taken in 1875 when Jennings must have been a very young man.

Quite how he obtained so lucrative a commission from the G.E.R. is not

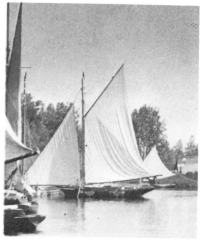

Wroxham Bridge (detail) J. Payne Jennings

The Broads being extremely shallow in places, most river craft generally drew less than three or four feet and had removable centre-boards which were dropped for added stability in the rivers and deeper Broads. Because of a levy on boats which was determined by keel length, a somewhat eccentric yacht design emerged. Large quantities of sail were essential, particularly high up where there was often a light wind. At the top of the mast above the mainsail was carried a topsail and forward of the mast an enormous jib was supported by a bowsprit almost as long as the vessel itself. The stern was countersunk to still further shorten the keel.

known, but as a photographer he was more than a match for the job and as a businessman he took full advantage of the opportunity.

In 1891 a collection of one hundred of his photographs was published as autogravures by Jarrolds. Entitled *Sun Pictures of the Norfolk Broads* on the last page there was an advertisement for the G.E.R. In the following year non-stop expresses were introduced from London to Cromer, and work was begun on doubling the track from Whitlingham to Wroxham.

The G.E.R. was increasingly vigorous in its promotions, which included publishing brochures detailing 'farmhouse accommodation' and boat-hiring facilities, donating copies of *Sun Pictures* and *Poppyland* to large public libraries, and running its own pleasure-steamer from Wroxham.

Payne Jennings photographed the North-East for another railway company and in 1895 produced another book entitled *Summer Holidays in North East England*. In 1897 he published, this time jointly with Jarrolds, a second edition of *Sun Pictures*, this time with captions by E. R. Suffling whose own book *The Land of the Broads* had been published in 1885. This edition carried an advertisement for Jennings's studio in Ashtead, Surrey. The last edition of *Sun Pictures* was published by Jennings alone, calling himself The Studio, Art Photo Works, Ashtead, and carried the crest of the G.E.R. on the front.

By the time Jennings's son was born in 1900 he was describing himself as 'Art Publisher' and he thus appears on the birth certificate. He was now living at Gayton House, a large Edwardian mansion surrounded by extensive grounds. His close neighbour and friend was Cadett of Cadett and Neal Limited, manufacturers of photographic equipment. He had become a wealthy man and in 1894 was a member of Ashstead's first Parish Council. Writing to a friend in 1909 he quotes Burns:

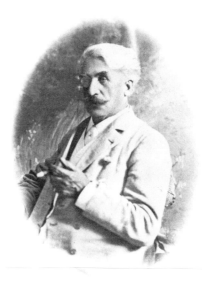

John Payne Jennings
photographed at the Rotunda Studios,
Dorking, in about 1918.

To catch dame fortune's golden smile	Not to hide in a hedge
Assiduous wait upon her	Or for a train attendant
And gather gear by every mile	But for the glorious privilege
That's justified by honour	Of being independent.

'Ormesby Broad'—one of Payne Jennings's
framed photographs from a G.E.R. railway
carriage.

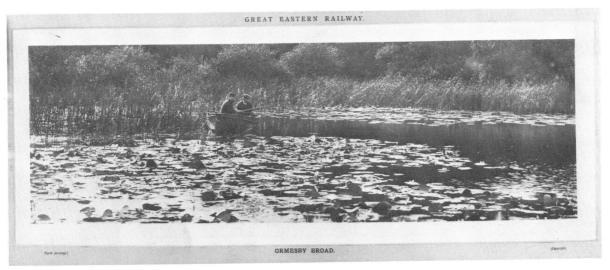

GREAT EASTERN RAILWAY.

ORMESBY BROAD.

One is reminded of the legend on the back of that early carte-de-visite: Il buon tempo verra' [The good times will come'].

He followed the idea that made him wealthy to the end. In 1911 he published *Some Beauties in Surrey and Sussex* for the London, Brighton and South Coast Railway.

Strangely enough, 1923, the year of Jennings's death also saw the demise of his patron the G.E.R., which was swallowed up by the London and North Eastern Railway.

More than anyone else it was the railways who were responsible for the development of Broadland and there is a touch of irony in the advertisement which appeared for the opening of the first Norfolk railway in 1844:

> Alas ye poor watermen what a mess you'll be in.
> In a short time on our River not a craft will be seen;
> Keels, Wherries and Packets will all turn out failures
> And we shall then bid adieu to our fresh-water sailors.

The reverse of a carte-de-visite taken by Jennings as a young man in about 1875 with the Italian motto 'Il buon tempo verra' above his name.

Art in Broadland

Peter Henry Emerson was born in Cuba of a wealthy family. After the death of his father and the war with Spain impending, his mother brought him to England where he completed his schooling and went on to read medicine at Cambridge University. He proved to be a man of outstanding ability, both academic and athletic. In 1885 at the age of twenty-nine he became a Fellow of the Royal College of Surgeons.

Emerson was a man of many enthusiasms, being a surgeon, photographer, meteorologist, writer of detective stories, naturalist, and champion billiards-player. Through an interest in bird-watching he first acquired a camera as a scientific means of recording material. Nevertheless, his agile mind soon became absorbed in the current debate concerning photography as art and art as photography. Photography at the time was painstakingly re-creating paintings from life as if by the medium of the camera, instead of the brush, the artist could better achieve his ends.

Emerson subscribed to the principle that photography was art but disagreed with the school of painting it was imitating. He advocated that photography should follow the Naturalist School of painters of which his friend T. F. Goodall was a member. He particularly admired Crome and Constable, making special note of the fact that the former often added, 'painted from life', to his titles.

His scientific mind added another dimension to the debate. He observed that the eye only focuses on the object of its attention and that everything in front, behind, and around is slightly out of focus. He also observed that the camera lens was capable of obtaining a much clearer image than the naked eye and he frowned upon the crystal sharpness displayed in the photographs of some of his contemporaries.

With these thoughts in mind, he and Goodall set off for the Norfolk Broads to photograph and paint. They produced a portfolio of forty photographs entitled *Life and Landscape on the Norfolk Broads* which was published as a limited edition by Sampson-Low in 1886. Each copy contained actual photographs painstakingly stuck in by hand and an accompanying semi-documentary text written by both Emerson and Goodall.

Emerson was so encouraged by this collection that he abandoned his career as a surgeon and launched himself into a vigorous and controversial

involvement with photography. During the next four years he produced *Idyls of the Norfolk Broads*, *Pictures from Life in Field and Fen*, *Pictures of East Anglian Life*, and *Wild life on a Tidal Water*. Then he abandoned photography with characteristic arrogance and intensity. 'The limitations of photography are so great that, though the results may and sometimes do give certain aesthetic pleasure, the medium must always rank the lowest of arts.'

Although disillusioned with photography as an art-form nevertheless his scientific mind continued to be absorbed by other aspects of the subject. In 1892 he was experimenting with telephoto lenses and in 1914 with stereoscopic slides and colour photography.

As seemed to be the case with Emerson, he was constantly working on two levels simultaneously. While he was busily engaged in creating 'art' with his camera he was also meticulously recording every aspect of rural life much as a naturalist would collect specimens. He went to enormous lengths to attain accuracy in the information accompanying his photographs. Almost unbelievably he penetrated the highly organized poaching rings and went so far as to argue their case in *Pictures of East Anglian Life*. As late as 1850 men were deported for poaching and in 1890 there were some 10,000 cases heard. Emerson objected to the fact that the same men whose game was poached sat on the Bench and passed sentences, often of great harshness and severity.

As a doctor he also remarks on the state of his subjects' health or their general physiognomy. Of the reed-cutters he says: ' . . . one of those whose life is a puzzle to the physiologist, for he has been exposed to all kinds of weather all his life; he has been badly fed, has drunk spirits enough to float a wherry and chewed tobacco enough to load it. Nevertheless he blithely carries his six-and-eighty years.' And of farm-workers: ' . . . both here and in Suffolk the smallness of the hands and feet is very noticeable.' And of the brickmakers he says 'these men suffer much from rheumatism'.

His books often contain statistical appendices on meteorology, agriculture, and bird and game sightings. He had the sort of mind that could produce *A Son of the Fens*, a novel in Norfolk dialect; *Suggested Amended Billiard Rules for Amateur Players*; and *Naturalistic Photography for Students of the Art*.

He was that strange product, more common in Victorian times than now, a man of great intelligence and independent means.

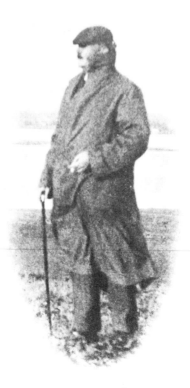

Peter Henry Emerson in later years.

Photography in Broadland

Davies furnishes an interesting link between the three photographers who quite probably never met:

> The writer was the first to photograph the Broads and publish his photographs. Since then Mr Payne Jennings has done a large number of very artistic photographs of the Broads, printed in platinum, which may be seen adorning the G.E.R. carriages. His volume *Sun Pictures of the Norfolk Broads* is a very interesting collection. Dr. Emerson and Mr. Goodall have also photographed, with more ambitious aims than merely to please the public eye, and artists, who are said to be good judges, rate their productions very highly.

The exact dates they were in Norfolk are unknown but Davies was definitely photographing at the Decoys at Fritton on Easter Monday 1882.

> Altogether we obtained sixteen negatives, all of them good and typical, and a set as unique as in a few years' time they will be valuable.

Emerson obligingly dates 'Sailing Match at Horning' 1885. Due to Jennings absolute reluctance to write a single word we only know his photographs were taken before 1890. Certainly the majority, if not all, the photographs in the book were taken between 1880 and 1890.

The equipment used by the trio was probably quite bulky. Emerson in search of perfection used the biggest camera he could reasonably manage, a 10 by 8 inch dry-plate camera. Since he considered the actual image made upon the plate by nature had some integrity he frowned upon enlarging and occasionally set out into the marshlands with a huge 22 by 24 inch camera to take exhibition prints.

All three used a tripod as a matter of course, the era of the quality hand-held camera and the concept of the 'snapshot' or 'instantaneous photograph' was yet to come. For those photographs taken on the water the camera was clamped to the gunwale and the boat staked to keep it steady. Davies describes the activities of the enthusiastic amateur:

> And now we became subject to the slavery of the photographic-box. Whenever we saw a picturesque drainage windmill, a cottage in a group of trees, ancient ruins, yachts or wherries, making a pretty picture, 'Oh, we must have that!' and the yacht was run up to the bank. The mate would drag forth the big box and deposit it on the skipper's toes, and the skipper would trip up the mate with the tripod. Then the mate would do the focussing and exposing, while the skipper 'shoo'd' off the too curious bullocks and cows, or dispensed valuable advice. We used the dry-plate process of course, and had the plates developed when we got home. We over-exposed most of them, for it seemed impossible that a second's exposure should suffice; and the skipper constantly urged, when not engaged with the cows, 'Give it another second to make sure'. Still we obtained a great number of excellent pictures, well worth all the tides and winds we lost through the constantly recurring delays.

And later: 'That night we sat up late changing the photographic plates in the darkened cabin, lit only by a dim red light.'

The photographs they took were from life. That is to say they contained real people engaged in genuine occupations. Certain exponents of photography, notably H. P. Robinson, felt country-folk were beneath photographing and used models dressed in their clothing. In his *Picture Making by Photography* of 1889 he recounts: 'It is not always easy to explain what you mean when you meet a girl in a lonely country lane and you offer to buy her clothes.'

All the pictures are, however, 'composed' rather than 'captured'. In Emerson's pictures the subjects are 'frozen' in carefully arranged compositions: The pictures of people in boats reveal not a ripple on the water. Even the oars in 'Rowing Home the Schoof-stuff' are completely motionless in mirror-still water, the boats probably being held by stakes out of sight of the camera.

Payne Jennings was typically business-like about his photographs. He took along a man and two wooden ducks to complete his compositions. His unknown assistant, who bears a passing resemblance to Jennings himself, appears on countless photographs, and the wooden decoy-ducks float unconcernedly and opportunely in the foreground.

E. R. Suffling is probably quite unwittingly amusing in one of his captions in the 1897 edition of *Sun Pictures of the Norfolk Broads*.

OLD HOUSEBOAT. SALHOUSE DYKE
Here we have a picture all ready for the artist to paint. A duck or two or a man is required to give life to a scene, and the picture is complete.

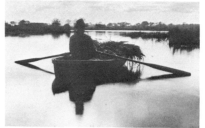

Rowing Home the Schoof-stuff P. H. Emerson

The apparent naturalness of this picture is an illusion. The boat, man, and oars are completely motionless.

Of the three the photographs of Davies are probably the least composed, but unfortunately he lacked the professionalism of Jennings or the mastery of Emerson.

Suffling states in the Introduction to *Sun Pictures of the Norfolk Broads*:

The numerous views which follow this short introduction are not mere book illustrations, but truthful reproductions of photographs of places and objects which have been taken direct with the camera . . . and to which no embellishments have been added for the sake of obtaining further quaintness or additional picturesqueness to various plates.

Emerson too produced 'undoctored' photographs contacted direct from the negatives. His only deviation was in the sky where he would sometimes heighten the cloud effect by giving a different exposure to that part of the plate or occasionally use a 'sky' from a completely different negative.

A feature of Jennings's photographs are the lowering skies, often full of menace. With the general geographical flatness of the Broads it is arguable that large expanses of featureless 'white' sky would have made for very uninteresting photographs. Whether Jennings patiently waited for genuine atmospheric effects or contrived them in his dark-room is unknown.

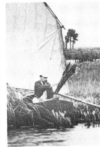
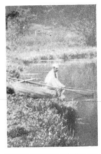

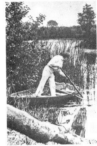

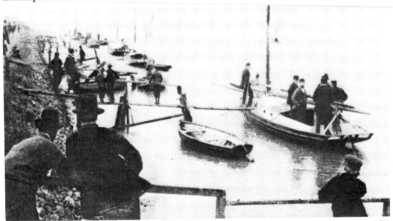

Breydon Water

G. C. Davies from *Norfolk Broads and Rivers* 1883

A photograph of Breydon Water by G. C. Davies. The scene is entirely natural.

Payne Jennings unknown assistant who appears in many of his photographs. In sparsley populated Broadland there was no guarantee that Jennings would meet anyone to populate his photographs so he took his own model, always suitably attired.

Life in Broadland

The Victorian photographers found a remote and rural community. The population was sparse and the landscape bleak, but to them it seemed a romantic idyl, an unspoilt paradise. In their descriptions they generally ignore any imperfections preferring to create the illusion of a life of tranquil self-sufficiency, lived out beside lily-covered lagoons. Their descriptions however are never as removed from reality as those of the Rev. Richard Lubbock describing the life of an eel fisher:

Our Broad, as he always called the extensive pool by which his cottage stood, was his microcosm, his world - the islands in it were his gardens of the Hesperides, its opposite extremity, his Ultima Thule.

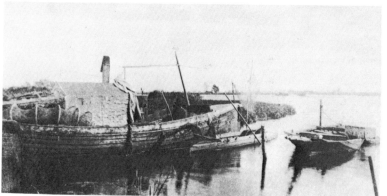

On Rockland Broad G. C. Davies from *Norfolk Broads and Rivers* 1883

but they came close.

There is a floating palace, and there are its king and its queen. True, the palace is but a large old sea-boat, with a hut built up in the centre third of it, and roofed with plans and tarred felt; but within, all is neat and snug, and spacious enough for the wants of its occupants. And he who sits mending his nets is more free than any monarch. His gun and his nets bring him enough for his needs, his house is his own, he calls no man master, and he pays neither rent or taxes. What more would you have? His wife is cleaning her crockery, and it is evident that she knows not the need or worry of a servant.

The contrast with the degrading squalor and oppressive working conditions of the time was inescapable. Even in East Anglia, virtually untouched by the Industrial Revolution, the conditions in Yarmouth and Norwich were appalling. In 1886, the infant mortality rate in Norwich was greater than one in five and the reports of the Medical Officer of Health between 1884 and 1889 record epidemics of typhoid enteritis and diphtheria. Overcrowding had reached crisis point in the built-up gardens of Norwich - the courts and yards; and the narrow streets of Yarmouth - the rows. By contrast, the wherrymen, eel-fishers, marsh cutters, fishermen and punt gunners who made up the Broadland community, were often self-employed and although game was preserved, the fish of the rivers and wildfowl of the marshes were free to all.

Occasionally a note of reality creeps into their descriptions but never for long.

> . . . the evening ended with much drinking and some fighting T. F. GOODALL

> The Norfolk peasant is fond of drink, and his sexual morality, to judge from the statistics of illegitimate children, is not without reproach. P. H. EMERSON

> Three or four men were holding a subdued colloquy over us. We could not distinguish what they said, but they remained debating something for a quarter of an hour and then moved off. What they were doing at two o'clock in the morning we did not think it prudent to enquire, and we remained apparently fast asleep. G. C. DAVIES

Despite their different motives for visiting Norfolk, and irrespective of their attitudes and ambitions, the three photographers have left between them a series of photographs which are eloquent testimony to their talents and an exceptional record of another age. MICHAEL SHAW

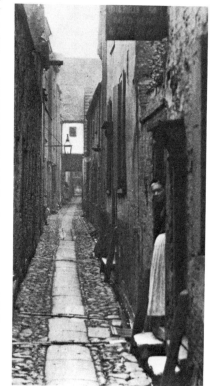

A Yarmouth Row P. H. Emerson

The Plates

The photographs of George Christopher Davies, Peter Henry Emerson and John Payne Jennings taken between the years 1880 and 1890.

The colour of the original photographs and photo-etchings has been adhered to as closely as possible.

The captions to the plates are from the writings of the photographers themselves or their close collaborators—T. F. Goodall in the case of P. H. Emerson and E. R. Suffling in the case of J. Payne Jennings.

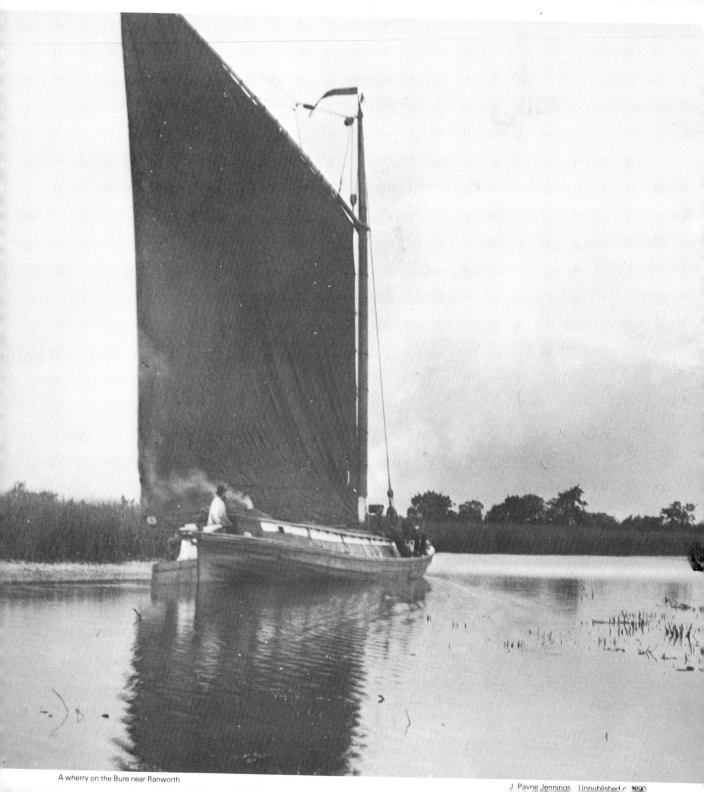

A wherry on the Bure near Ranworth

J. Payne Jennings Unpublished c. 1890

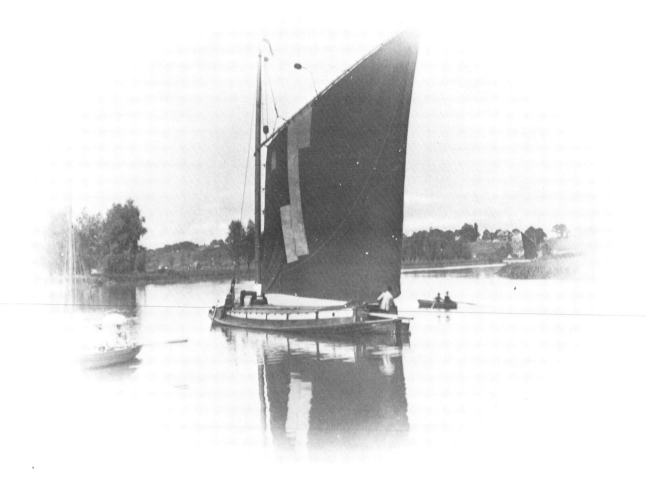

Wherry leaving Coldham Hall

J. Payne Jennings from *Sun Pictures of the Norfolk Broads* 1891

Wherries

One can hardly imagine the Broads without wherries. They are to be seen moored at every staithe, as well as in the most sequestered bights, often giving no sign of life save that of the galley fire, whose smoke curls lazily upwards. If it be summer time, the skipper's family, dog and all, will be seen on deck from morn till night. At nearly every bend of the river the brown mainsail, filled by the breeze, will quickly carry the curious craft out of your sight, whilst you are wondering whence appeared this picturesque barge, and whither it is bound.

These vessels are built of oak, with the exception of the masts and gaff, which are made of American fir. Their average register is twenty-five tons. A portion is separated from the hold at the stern, and fitted with seats and lockers, a stove being placed amidships. Two are required for a crew, and although at times one man can manage, they always 'look to have two men', as they say. These men are paid by the voyage, an average wage being thirty shillings from Norwich to Yarmouth, and they have bills of lading just like merchantmen. Some firms have tried to introduce steam wherries, and on the Yare they are successful, but not on the Bure or Thurne, for on these latter rivers weeds are so common that the propellers get clogged.

P. H. EMERSON

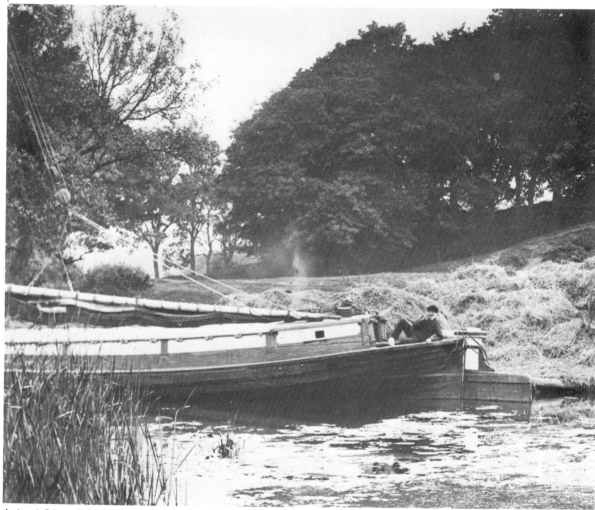

A wherry in Salhouse Dyke

J. Payne Jennings from *Sun Pictures of the Norfolk Broads* 1891

There is a little cabin in the stern, and abaft of this the steersman stands against the tiller, with the sheet working on the 'horse' on the top of the cabin just in front of him. There are a large number of men employed in this kind of navigation and as a rule they are sober, honest and civil men, ready to give any assistance in their power to the yachtsman. A great weakness of theirs is a fondness for tea. This they boil in the kettle, which then never 'furs'. A wherryman told us he drank two large *basinfuls* at each meal.

GEORGE CHRISTOPHER DAVIES

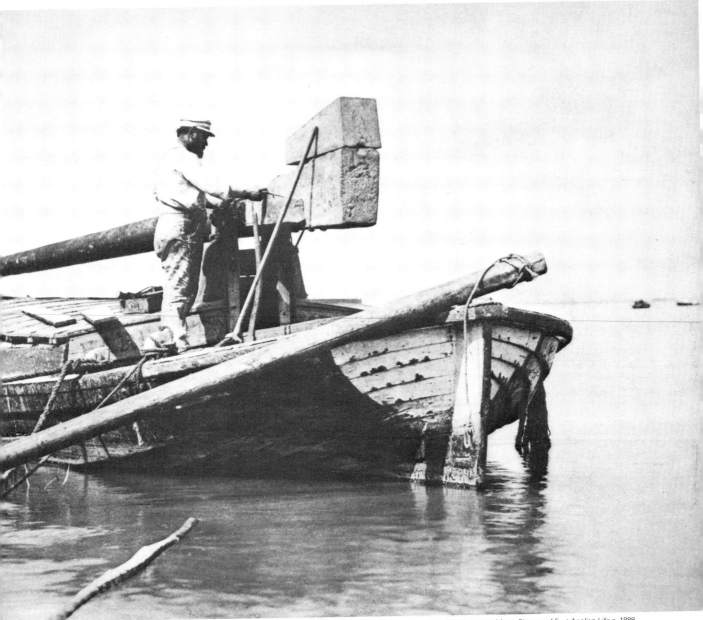

Mending the Wherry

P. H. Emerson Plate XIX [substitute] from *Pictures of East Anglian Life c.* 1888

The wherries are built entirely of English oak, and a large one will cost about £500, including the sail and the ton and a half of lead which is bolted on to the heel of the mast, to act as a balance on lowering and raising it.
The mast, having no stays to support it except a forestay, must be very stout and strong. They are made of Spruce fir and are very massive: yet we have seen a little girl amuse herself rocking a mast up and down so carefully was it balanced.

GEORGE CHRISTOPHER DAVIES

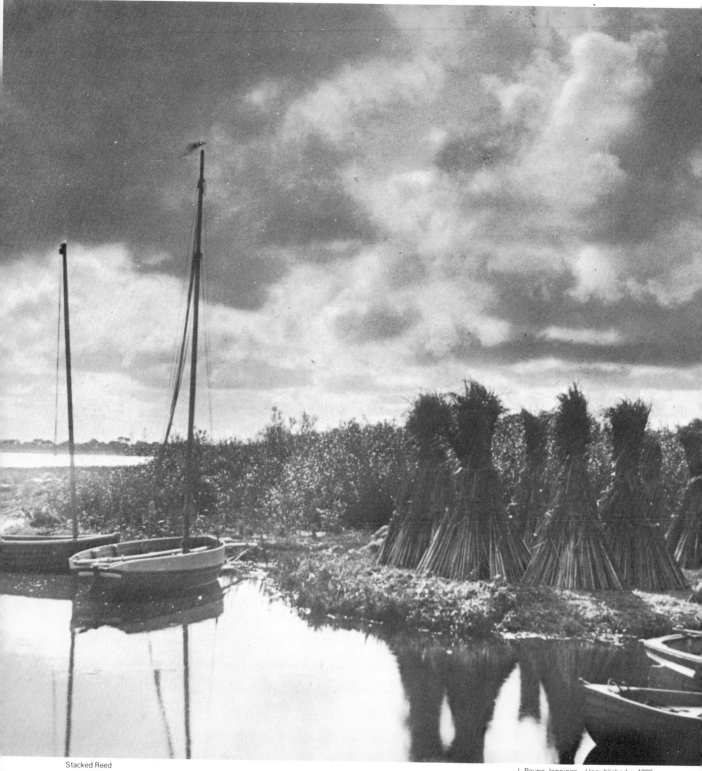

Stacked Reed

J. Payne Jennings Unpublished *c.* 1890

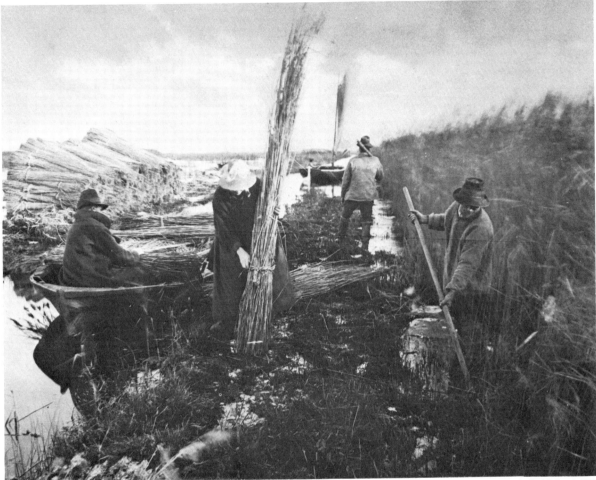

During the Reed Harvest

P. H. Emerson Plate XXVIII from *Life and Landscape on the Norfolk Broads* 1886

Marshland Harvests — Reed

By far the most valuable product of the swamps and rough marshes adjacent to the Broads, is the crop cut yearly from the reed beds which form so prominent and picturesque a feature in the landscape. The dense green masses of this plant, so characteristic of the Broads in the summer time, after putting forth their purple flower tassles, and undergoing the most beautiful changes of subtle and delicate colour in the autumn, shed their leaves, and by Christmas nothing remains but the tall, slender, sapless stems with the withered flowers at the tips.

The cutting and harvesting of the reed afford profitable employment to the Broadman, marshman, or farm-hand during the winter months, when other work is scarce; and whenever the weather permits they may be seen busily plying the meak amid the tall yellow masses, or bringing the loaded marsh-boat across the Broad.

T. F. GOODALL

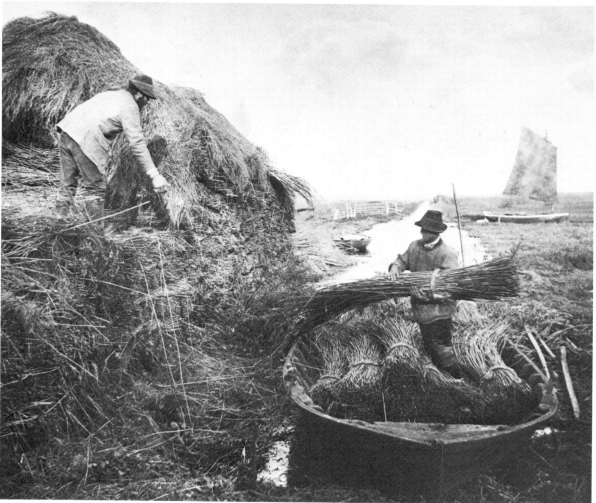

Ricking the Reed

P. H. Emerson Plate XXVI from *Life and Landscape on the Norfolk Broads* 1886

Being a piece-worker, the reed-cutter is his own master, and consequently the work is much in demand by those men—often some of the best hands—who like, occasionally, to relieve the monotony of existence by a prolonged drinking-bout, or to whom the attractions of a coursing meeting on the marshes, or a shooting match, are irresistible. When cut, the shooves are stood on end, leaning against each other in stacks on the bank of the nearest dyke, till the marsh-boat conveys them to the staithe, where they are ricked.

T. F. GOODALL

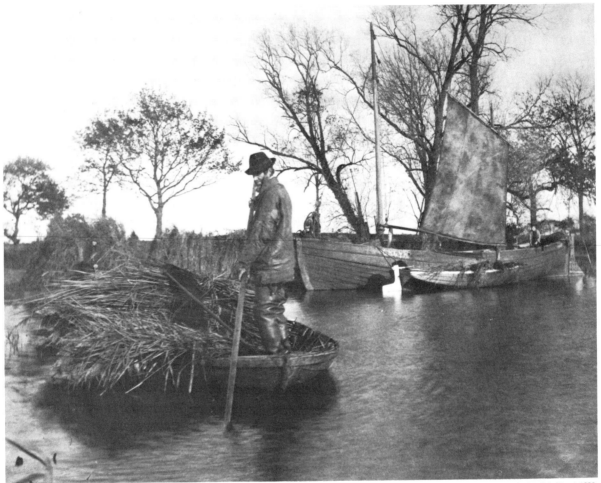

The Gladdon Cutters Return

P. H. Emerson Plate XXXIII from *Life and Landscape on the Norfolk Broads* 1886

— Gladdon

By gladdon we understand the common bullrush. The young shoots of the plants of this order are sometimes boiled and eaten as a vegetable.

The cutting begins directly after the harvest, when the blade has just begun to turn yellow. The choicest, which is used for braiding purposes, is cut first. When the cutter has a good load he pulls up his quant and pushes his boat ashore either to a bank or a staithe. Here the bundles are taken out, placed on their ends and allowed to 'weather' in the sun. This turns it golden brown and toughens it.

When cured it is sold to mat and horse-collar makers. It is also used, mixed with reed, for thatching, but the mixture is not considered so good as the reed alone.

P. H. EMERSON

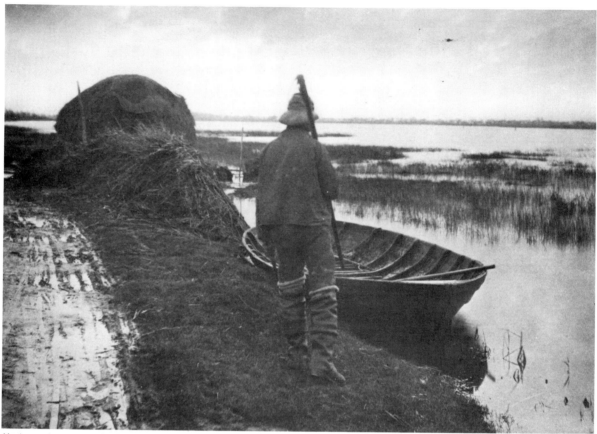

Marshman going out to cut schoof-stuff

P. H. Emerson Plate XXII from *Life and Landscape on the Norfolk Broads* 1886

— Schoof-stuff

The word 'schoof' or 'schoaf' is derived from the Dutch *schoof,* and originally meant a sheaf of wheat: from this it came to mean, in Norfolk at least, a sheaf of anything, for there we constantly hear of schooves of gladdon, schooves of reed. Schoof-stuff. however, has a distinct meaning of its own. and is used to describe the crop of marsh-plants which, too rough for fodder and too mixed for thatching, are yet cut to be used for covering beet, for stable litter, and finally for manure. The chief plants comprehended under the name schoof-stuff are the bolder, yellow-iris, inferior gladdon, bur rush, sweet rush, common rush, sword grass, *carices*, rush grasses, bents, fescues, hair grasses, cotton grasses, and others which thrive in marshes and lands periodically flooded.

P. H. EMERSON

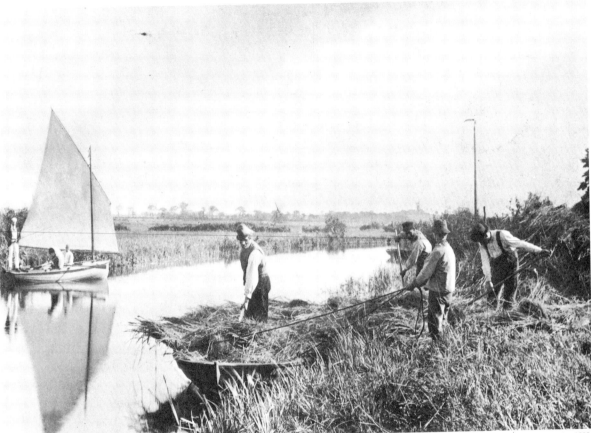

Cutting and transporting the Marsh Hay on the Ant

J. Payne Jennings Unpublished *c.* 1890

— Marsh Hay

Long after haysel is over on the uplands the marshmen are busily engaged, under the broiling sun of July and August, cutting and carrying, by land or water, the heavy green crops from the marsh land. The more cultivated and thoroughly-drained marshes yield a hay of high quality, while the rough stuff which grows in abundance on the half-drained ground, or on the rands and walls of the river, though too coarse for fodder, makes valuable litter. Splendid the mowers look, as they sweep down the tall rank herbage; their loose shirts, of white or blue cotton, gleam in the sunshine; their legs are encased in the tall marsh boots, without which they could not work in comfort on the swampy soil. Strapped to their backs are their hones; wide, soft felt hats cover their heads, picturesquely shadowing their faces. Superb is the action of the men as they bend to the heavy work, or, standing with booted legs wide apart, hone their scythes, or wipe the gathered moisture from their faces.

For an hour before and after noon they rest from their labour. Forming a social group in the shade of the alder bushes, each one eats the 'bit of wittles' brought to him along the marsh wall by wife or daughter, now and again taking a long drink of cold tea, or home-brewed from the bottle. The meal over, some doze, others angle in the river, till the two resting hours have sped.

T. F. GOODALL

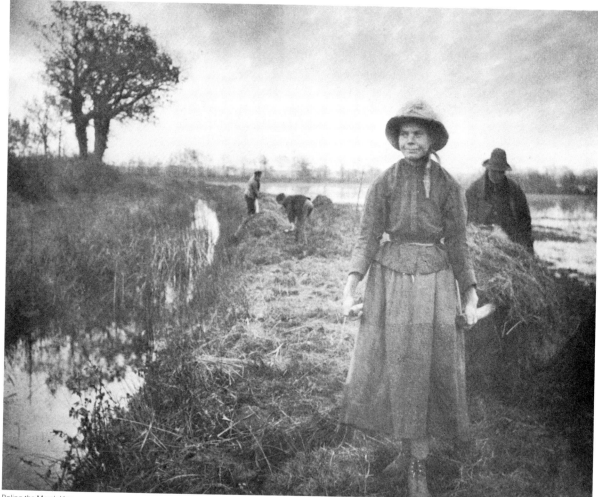

Poling the Marsh Hay

P. H. Emerson Plate XVII from *Life and Landscape on the Norfolk Broads* 1886

When dry, the hay is forked up into heaps: these are borne to the nearest dyke on two poles, passed underneath in such a manner as to support the load when carried by two men walking between them, one in front of and one behind the burden. This picturesque mode of conveyance is adopted because the load has to be carried over ground so soft that cart or barrow would be worse than useless.

T. F. GOODALL

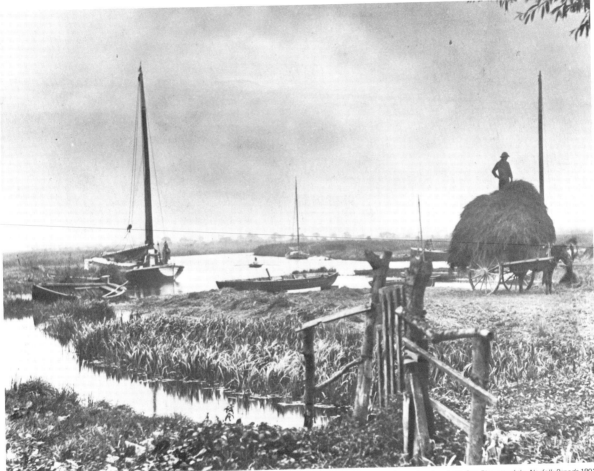

J. Payne Jennings from *Sun Pictures of the Norfolk Broads* 1891

Loading rushes, Barton Dyke

At the dyke the hay is pitched into large flat-bottomed boats, and rowed or quanted away to some staithe, where it is piled on shore ready for the waggons which bear it away to the farmyard.

T. F. GOODALL

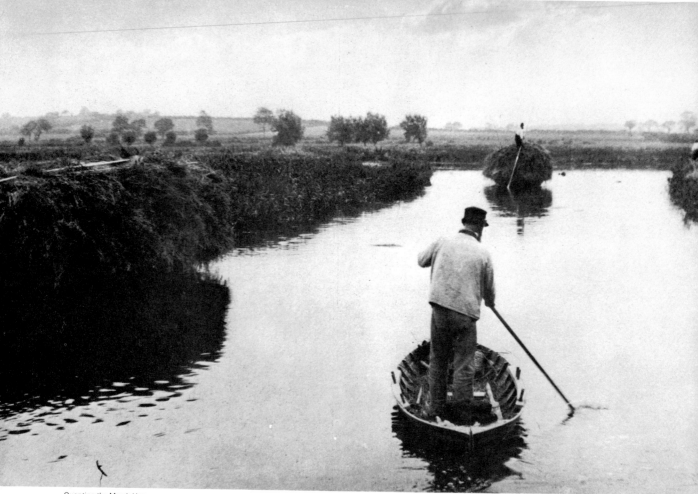

Quanting the Marsh Hay

P. H. Emerson Plate XVI from *Life and Landscape on the Norfolk Broads* 1886

These flat-bottomed, broad-built boats are one of the features of these waters and are propelled by means of a long pole, called a "quant." These boats, of funereal black, are the local gondolas, and the gondolieri, here known as the marshmen, are very expert in "quanting" the sombre craft from place to place. Indeed, to quant a boat well requires great practice, and many a novice has received a gratuitous bath, concurrent with a lesson in this mode of progression. Immense loads of marsh-hay and rushes are conveyed by these boats, which are frequently so hidden as to cause the spectator to fancy he sees a man navigating a haystack along the stream.

E. R. SUFFLING

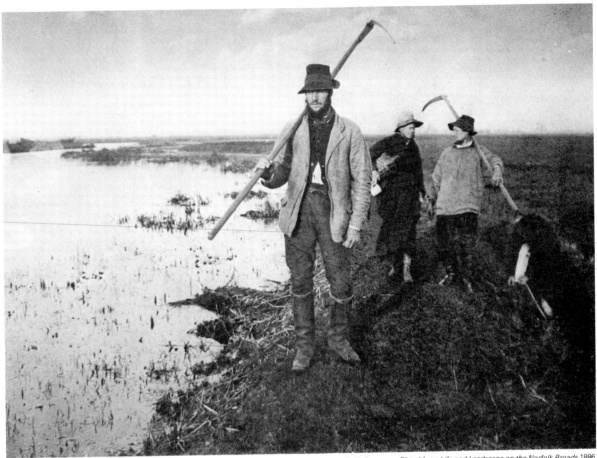

Coming home from the marshes

P. H. Emerson Plate I from *Life and Landscape on the Norfolk Broads* 1886

Along the marsh wall comes a group of labourers returning from their day's work. Typical specimens these of the Norfolk peasant, —wiry in body, pleasant in manner, intelligent in mind. Their lot, though hard, is not unpleasant. Much of their work is that of an agricultural labourer, but in this part of Norfolk it is more varied than in ordinary agricultural districts. They have just returned from cutting the reed. Protected by their long marsh-boots, they may be classed as 'waders', for they spend much of their time standing in water up to their boot-tops. Nevertheless they are happy and healthy. The octogenarian who is down the bank lacing his boot, is one of those whose life is a puzzle to the physiologist, for he has been exposed to all kinds of weather all his life; he has been badly fed, has drunk spirits enough to float a wherry, and chewed bad tobacco enough to load it. Nevertheless he blithely carries his six-and-eighty years.

P. H. EMERSON

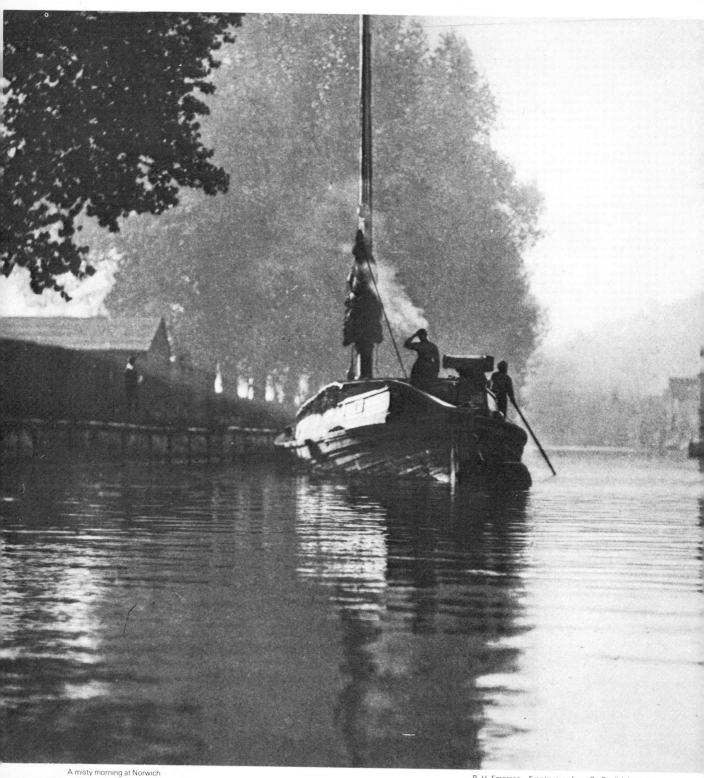

A misty morning at Norwich

P. H. Emerson Frontispiece from *On English Lagoons*

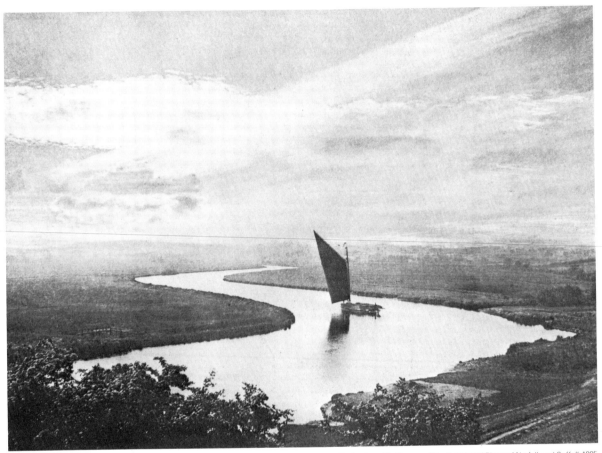

Whitlingham Reach from Postwick

George Christopher Davies from *The Scenery of the Broads and Rivers of Norfolk and Suffolk* 1885

The Wensum and the Yare

It was an hour before we got under way again, and when, after sailing down the long straight reach by Whitlingham, we came in sight of the eminence known as Postwick Grove, Wynne wished to land in order that he might see the view from the top. Well, the view from Postwick was worth seeing. The curving reaches of the river, animated with yachts, wherries, and boats, lay beneath us, and the green marshes were bounded by the woods of Thorpe, Whitlingham, and Bramerton, while the ruined church of Whitlingham stood boldly on the brow of the opposite hill.

GEORGE CHRISTOPHER DAVIES

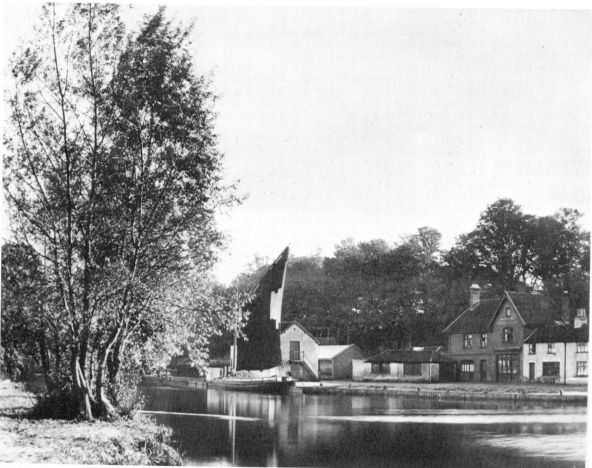

Wood's End P.H., Bramerton

J. Payne Jennings Unpublished *c.* 1890

Under way again, we presently reached Bramerton, where the "Wood's End" public-house offers good cheer to the wherrymen and boating-man.
The pleasure-steamers which run between Norwich and Yarmouth afford a quick but less pleasant way of seeing the river, and stop at Bramerton nearly every day in the week.
Now the higher ground falls away from the river on each side of us, and the belt of marshes widens, the river is higher than the surface of the land, and the water is lifted out of the many drains and dykes by means of turbine wheels, worked by the windmills which form such conspicuous objects in the landscape, and by more pretentious steam drainage mills.

GEORGE CHRISTOPHER DAVIES

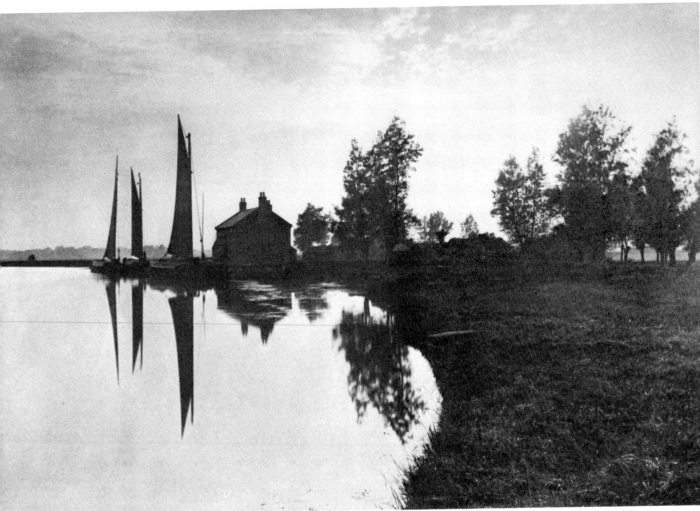

Cantley. Wherries waiting for the turn of the tide

P. H. Emerson Plate XXIV from *Life and Landscape on the Norfolk Broads* 1886

The wherrymen are a fine set of men, and require all their strength for their work. It is a regular occupation, and the men, jealous of outsiders, do not care to take any crew not brought up to the work from boyhood. They are very respectable, drink little, and have a wondrous fellow-feeling for each other. They carry very little beer with them, but drink cold tea to quench their thirst. When they arrive at a waterside tavern, however, they assemble in the taproom and enjoy their beer. This is usually when there is a 'shoulder-breeze' on or, in other words, when wind and tide are unfavourable, and they must use the quant. They are sportsmen in their own way, and can be seen at times eel-picking as they sail along, or trolling for pike. In the evening, when at rest, they fish for eels or bream. In winter they carry a gun, and, with their dog, manage to provide themselves with plover and other wild-fowl. Our plate shows two wherries waiting at Cantley for the turn of the tide. This is a famous half-way house, and often in summer one will see them thickly congregated round the staithe.

P. H. EMERSON

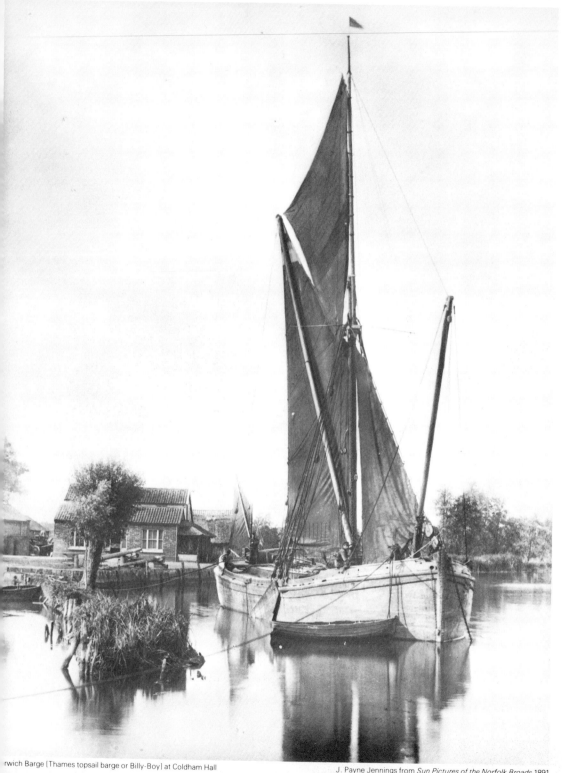

rwich Barge [Thames topsail barge or Billy-Boy] at Coldham Hall

J. Payne Jennings from *Sun Pictures of the Norfolk Broads* 1891

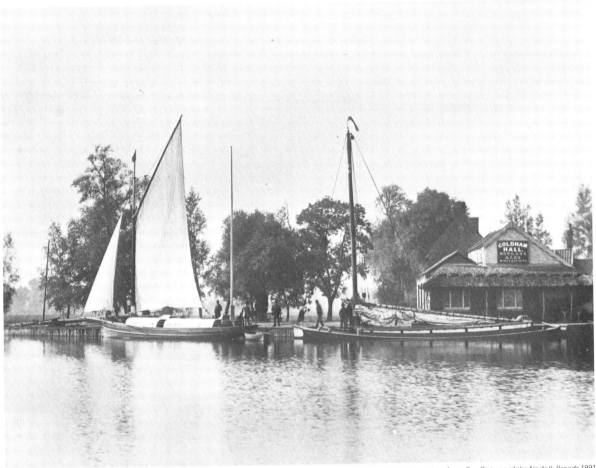

Coldham Hall

J. Payne Jennings from *Sun Pictures of the Norfolk Broads* 1891

After fishing-matches on the river, the green in front of the inn at Coldham Hall presents a curious spectacle. A huge pair of scales, which could weigh a jockey, is hard at work weighing the catches, and the heaps of fish are laid out in a row for admiration and discussion. The fate of kingdoms does not excite the interest which accompanies the arrival of each boat at the close of the hard-fought day.

GEORGE CHRISTOPHER DAVIES

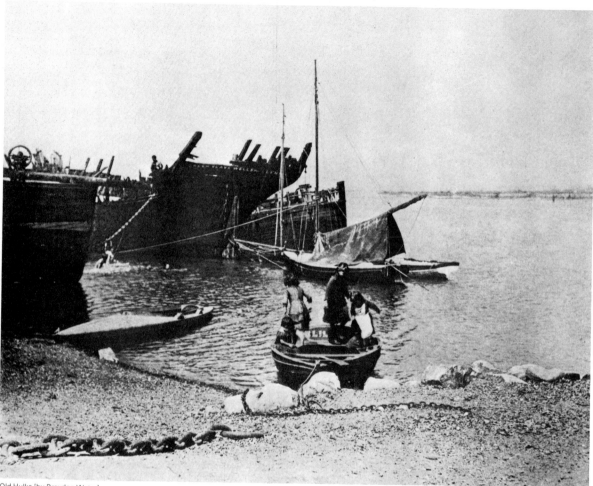

Old Hulks [by Breydon Water]

P. H. Emerson Plate IV from *Wild Life on a Tidal Water* 1890

Below the little water-side inn known as the "Berney Arms," the channel of the Yare narrows and the tide runs swiftly, and there the river meets with its sister from the pleasant vales of Suffolk, the clear-running Waveney. Together they expand into the fulness of Breydon Water, at the distant misty end of which rise the spires and towers of Yarmouth. When the tide is in, Breydon (the "broad end" of the rivers) is indeed a noble lake; but the parallel rows of posts down its mid-length tell of a channel that must be kept with great exactness, and of mud-flats dry on either side at low water.

On the south bank, close to Yarmouth, are little shanties and boat-houses rented by yachtsmen and sportsmen, and it is in these that the greatest sport seems to us to be had, for the enthusiastic gunners sit and smoke, and fondle their big guns, and talk of what they have done and will do in a very pleasant and edifying way.

GEORGE CHRISTOPHER DAVIES

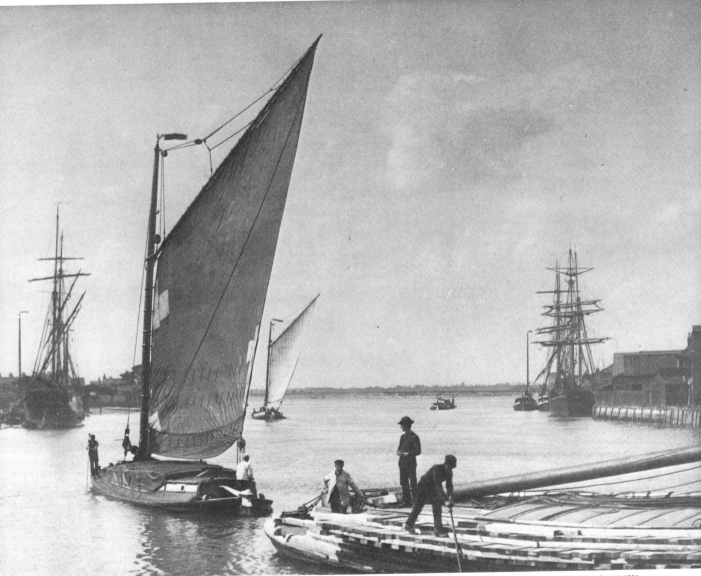

Wherries leaving Yarmouth for the Broads

J. Payne Jennings from *Sun Pictures of the Norfolk Broads* 1891

When the wind fails or the tide is unfavourable, then men betake themselves to the 'quant', which is a long slender pole with a knob at one end and a spike and shoulder at the other. The shoulder is to prevent the quant sinking too far into the mud. The wherryman plunges the quant into the water at the bow of his craft, and placing the knob against his shoulder, walks aft along the plank ways, pushing with all his might.

GEORGE CHRISTOPHER DAVIES

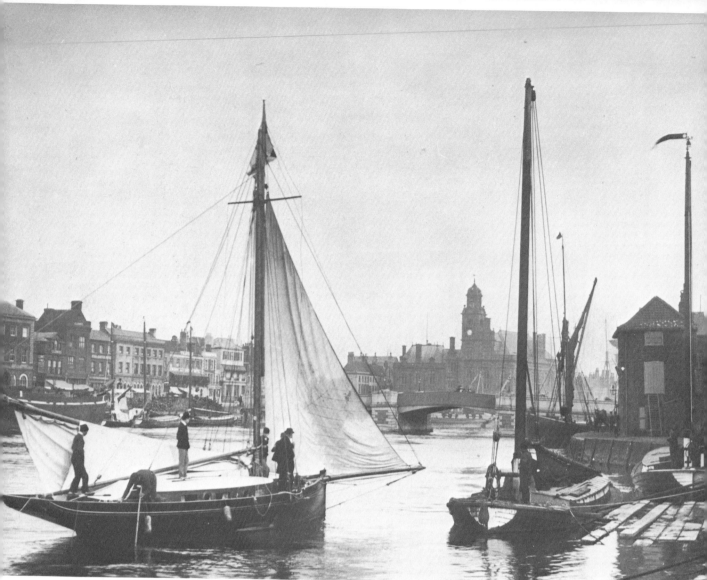

Home from the Broads, Yarmouth

J. Payne Jennings from *Sun Pictures of the Norfolk Broads* 1891

A sail across Breydon in a strong wind, is a thing I always consider a great treat. The channel is marked out by stout posts at intervals of two hundred yards or thereabouts but it is not safe to sail too close to all these posts unless the tide be high, as the shoals stretch out beyond them, and, in default of local knowledge, it is best to give them a wide berth.

The spires of Yarmouth grew more distinct, and at last we arrived at its quays, just as the tide was on the turn. We made fast alongside a wherry moored to the quay, and while our man, with the assistance of one of the loiterers on the quay, lowered the mast, and quanted the yacht up the narrow mouth of the Bure and under two bridges, we took a stroll about the quays, the quaint "rows" and streets of the old part of the town, and had a peep at the splendid church.

GEORGE CHRISTOPHER DAVIES

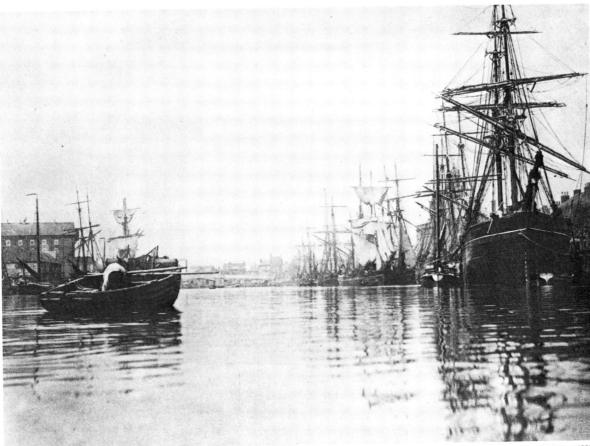

The Peaceful Harbour

P. H. Emerson Plate XXIV from *Wild Life on a Tidal Water* 1890

People were hurrying with anxious faces to the pier, and groups of women were silently watching the boats arrive. As we reached the pier, the first thing we saw was a smack being towed up with full fifty men at the hawser. The gale was from the west, and dead against a vessel attempting to enter. The tide was running out with great violence; the fall in the level from one point to another was easily discernible. With all their strength the men could only tow the smack at a snail's pace against wind and tide. They would halt perforce for a second or two, and then with an effort proceed a few yards, and so on until they reached the northerly bend of the river, which enabled the smack to hoist her jib and run up stream. Joining the crowd at the end of the pier, we watched a Scotch lugger making for the harbour. Her mainsail only was set, and was close-reefed, and she was evidently heavily laden with fish—the herrings gleaming in the folds of the net, which lay on the deck, where it had hurriedly been hauled in when the gale broke. It was a fine sight to see how the little craft rode over the heavy seas which every now and then smothered her in foam. She could make the harbour mouth, but no further, by the aid of the wind; and as she dashed close up to the south pier a coil of light rope was hurled by a strong arm, and fell on the deck, where the end was immediately seized, and bent to the end of a stout warp, which was quickly hauled on shore, and then manned by a score of stout fellows, who succeeded in towing her up.

The only reason the gale is alluded to is to show how defective as harbours of refuge both Yarmouth and Lowestoft are.

GEORGE CHRISTOPHER DAVIES

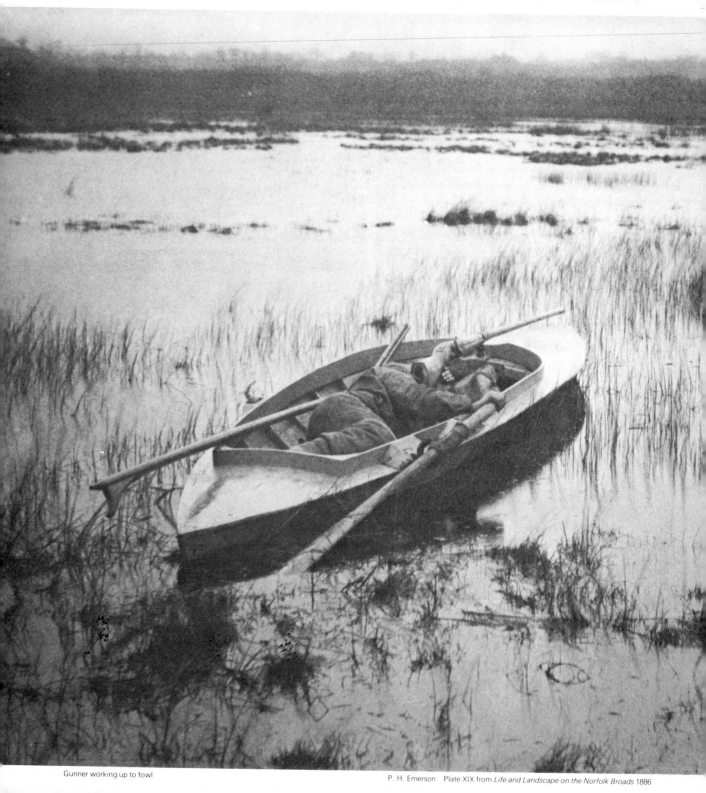

Gunner working up to fowl

P. H. Emerson Plate XIX from *Life and Landscape on the Norfolk Broads* 1886

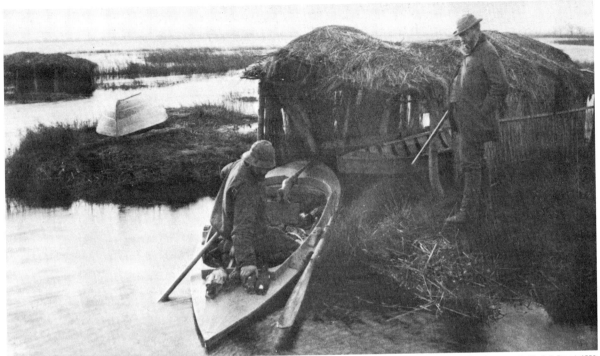

The Fowler's Return

P. H. Emerson Plate XX from *Life and Landscape on the Norfolk Broads* 1886

Wild fowling

No boat is handier, or more perfectly adapted to its special purpose, than the gun-punt. The draught of water being only a few inches, the shallowest places are easily accessible to it. The bottom is flat from side to side, but curved slightly from stem to stern, like the line of a skate-blade. The sides, which converge to a point at either end, are flat, and slope outwards at a slight angle— the floor of the boat being of less area than the top. As may be seen in the pictures, the centre only of the boat is open, the ends being covered with a gently-sloping deck. A first-class gun-punt has very subtle lines, and can only be built properly by the most intelligent of boat-wrights, and perhaps only by one who is himself a gunner. The punt can be sailed, rowed, quanted, or sculled, is light and fast, while its exceedingly low freeboard offers a minimum of resistance to wind and wave when the weather is boisterous. Under the decked ends are stowed the ammunition, the shoulder-guns, the oiled coat and sou'-wester, the snack of food and drop of rum, and other needs or comforts of the gunner.

The big gun is nicely poised on a swivel, the stout iron pin of which works in a socket drilled into a massive block of hard wood, which, according to the size of the weapon, is either fixed or allowed to slide in a short run on the bottom of the boat, the recoil being checked by a powerful spring. Boat and gun are painted a leaden grey, or, as the men will tell you, 'the colour of the water,' invisibility being the most desired attribute of the wild-fowler.

In our first picture a gunner, in the grey morning light, which the tone of the plate so well renders, is sculling up to some fowl which he has marked down among the rushes in a shallow corner of the Broad. Lying right down in the bottom of his punt, no part of him can be seen from the water, save the hand which grasps the short straight-bladed oar with which he sculls. Like all the gunners, he is wonderfully adept in this method of propulsion—working up to the birds swiftly and noiselessly, and steering with great facility. From his prone position he is just able to see his course, and train the gun, without alarming the wild-ducks.

P. H. EMERSON

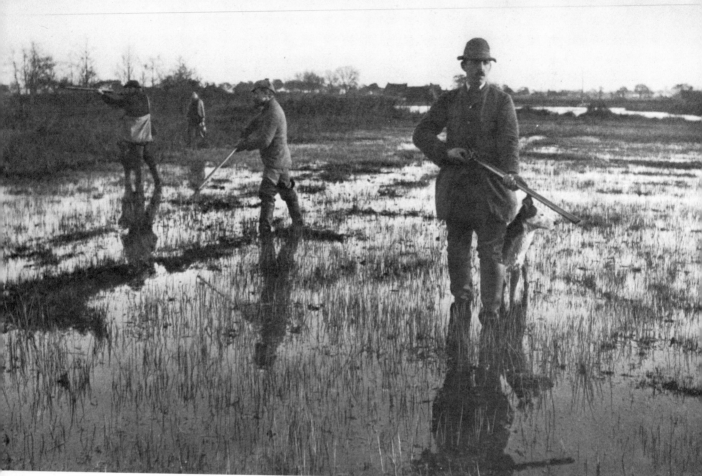

Snipe Shooting

P. H. Emerson Plate X from *Life and Landscape on the Norfolk Broads* 1886

The marshes at Surlingham and on the opposite side of the river below Coldham Hall, are among the best snipe-grounds in the country; and on any spring or summer day you may hear the bleating of the snipe and see the birds in two or three directions at once, and at the same time hear the whistle of the redshank.

GEORGE CHRISTOPHER DAVIES

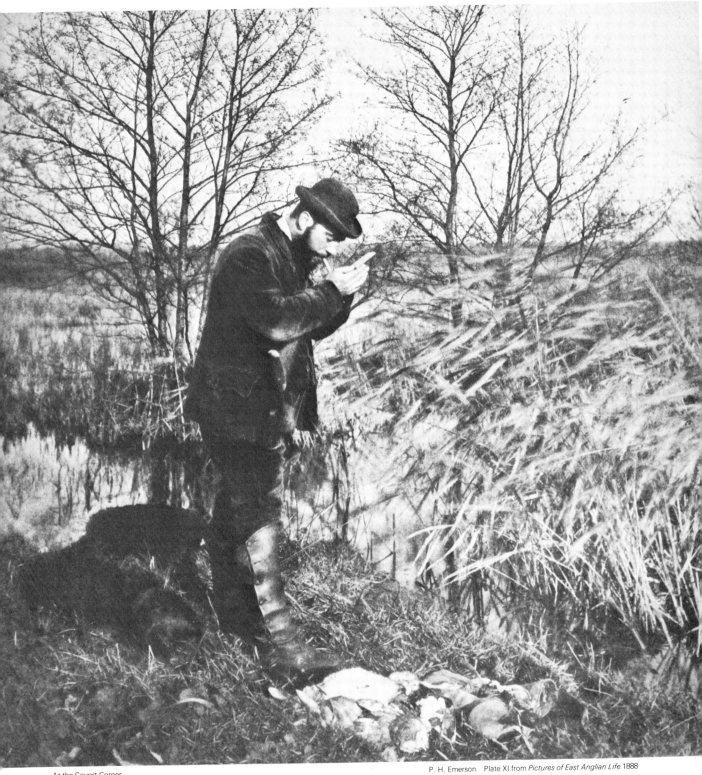

At the Covert Corner

P. H. Emerson Plate XI from *Pictures of East Anglian Life* 1888

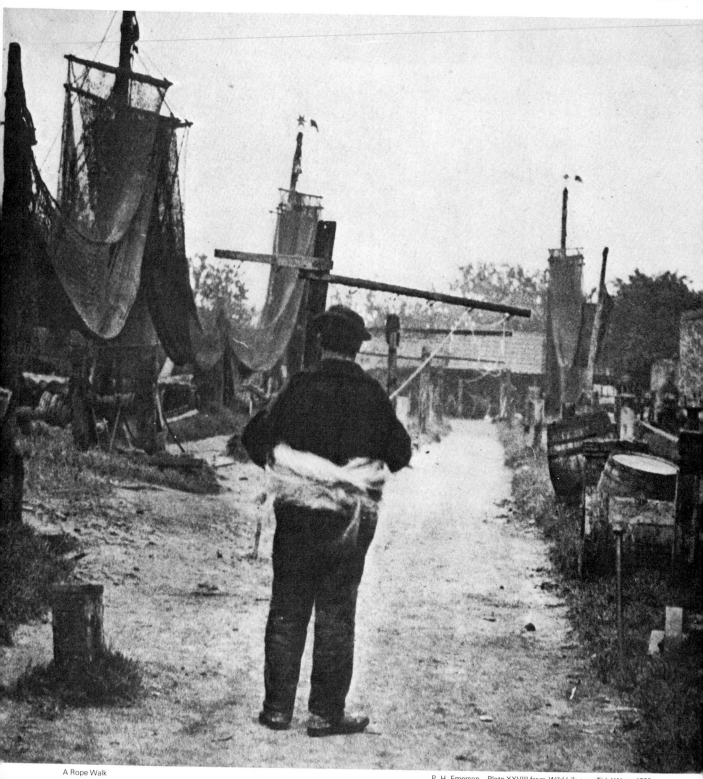

A Rope Walk

P. H. Emerson Plate XXVIII from *Wild Life on a Tidal Water* 1890

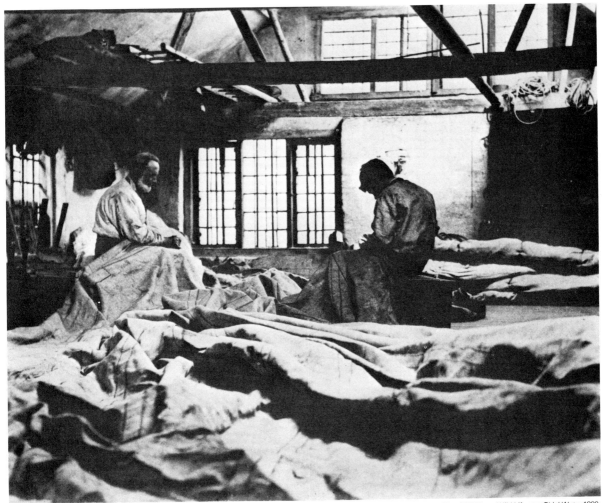

In a Sail-Loft

P. H. Emerson Plate XVIII from *Wild Life on a Tidal Water* 1890

Yarmouth Crafts

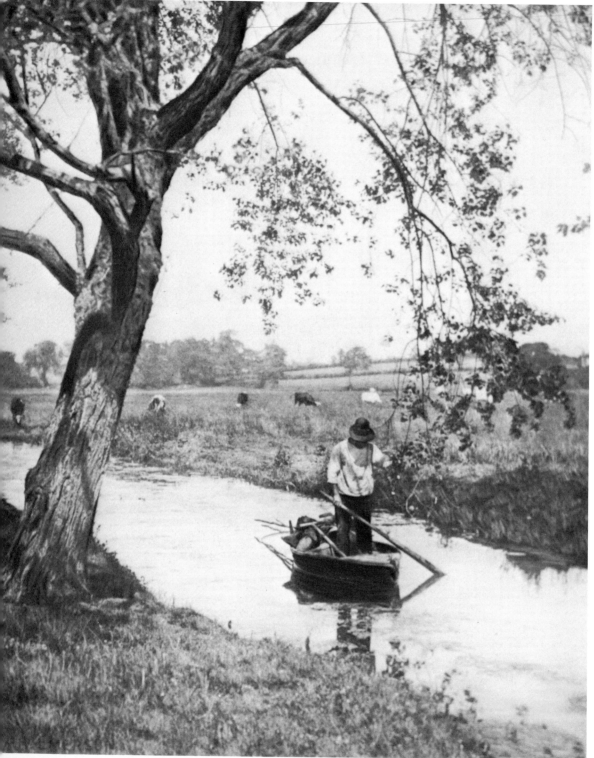

Suffolk Dyke

Peter Henry Emerson Plate IX from *Pictures from Life in Field and Fen* 1887

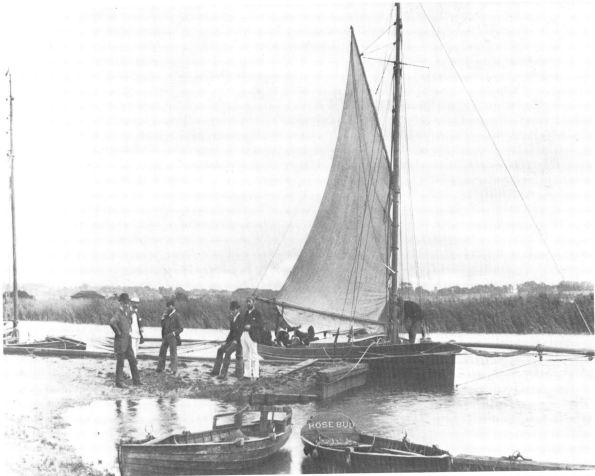

Yachts on the Waveney

J. Payne Jennings from *Sun Pictures of the Norfolk Broads* 1891

The Waveney

The old yachts were simply called pleasure-boats, and this just describes them to a nicety. The lack of railway and inn accommodation and the length of water-way rendered a cabin necessary, and so all the small yachts have cabins, in which two persons can pass a night or two without much discomfort, and a large open well, which gives plenty of space for day passengers. In some of the older boats the keel was barely half the extreme length of the boat. This was partly to gain handiness, and partly to cheat the measurement rule, which was formerly (and still is, Barton and Hickling way) the length along the keel or "ram." A large immersed counter is the rule with all the yachts, and the bowsprit projects outboard about the length of the keel. A 3-ton cutter would have a boom of 25 feet, a gaff of 20 feet, and bowsprit of 17 feet outboard, the actual length of the boat itself being 23 feet. Without going further into technical details, it will be seen that these small craft carry an enormous amount of canvas.

GEORGE CHRISTOPHER DAVIES

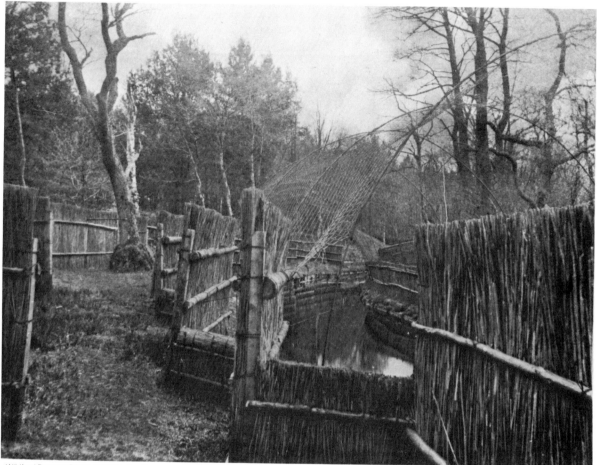

Wildfowl Decoy at Fritton, Looking up a pipe George Christopher Davies from *The Scenery of the Broads and Rivers of Norfolk and Suffolk* 1885

Fritton Lake is not, strictly speaking, a Broad, as it is not connected with or a broadening of any river. It is also out of the marsh district, in a sylvan part about three miles from the coast, and midway between Yarmouth and Lowestoft, and is really a deep lake, about three miles long and a sixth of a mile wide, of a straggling and irregular shape, lying between wooded banks of great beauty, and with numerous creeks or indentations, of which advantage has been taken to construct the decoys.

The keeper gave us a bit of smouldering turf, the object of which is to destroy the human scent, which would otherwise travel down wind and alarm the ducks.

Like all other birds, ducks like to swim or rise with the wind in their faces; hence it is only possible to work those pipes which are to windward of the birds, and in all decoys there are pipes made to suit the prevailing winds.

Beyond a flock of teal were several decoy-ducks—tame ducks of a colour and marking as nearly as possible like the mallard. These decoy-ducks are kept in the decoy, and trained to come in for food whenever they see the decoy-dog, or hear a low whistle from the decoy-man. Beyond the decoy-ducks was a flock of mallards, looking large and sitting high on the water compared with the teal.

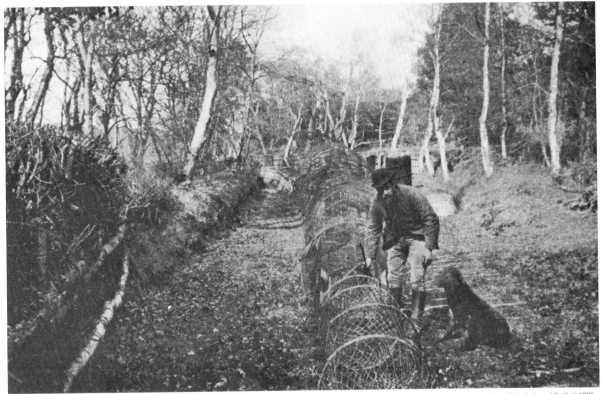

Wildfowl Decoy at Fritton, purse net at end of pipe
George Christopher Davies from *The Scenery of the Broads and Rivers of Norfolk and Suffolk* 1885

At a sign from the keeper the obedient decoy-dog jumped over one of the jumps on to the narrow strip of margin within the pipe, and so became visible to the fowl, returning to his master over the next one. In an instant every head was up among the teal, and with outstretched necks they swam towards the dog, their bright eyes twinkling, and every movement indicating a pleased curiosity. They halted as the dog disappeared; but as, at a sign from the keeper, he jumped into the pipe again higher up, the birds again eagerly followed him. They were now well within the pipe, and directly under my nose. The keeper ran silently towards the mouth of the pipe, so as to get behind them; and then appearing at one of the openings between the screens, he waved his handkerchief,—a motion invisible to the ducks still outside the pipe, but a terrifying sight to those within. In an instant they rose and flew up the pipe in a panic, the man following them up and waving his handkerchief at each opening. As the pipe grew narrower, the doomed birds struggled along, half flying, half running. Only one dared to turn back and fly out of the pipe, regaining safety by its boldness. The others crowded through into the tunnel net; and when all were in, the keeper detached the first hoop from the grooves, gave it a twist, and so secured the ducks.

As we ran up after the keeper, one of us took the opportunity of straightening his back, thinking that all necessity for further concealment was at an end. Immediately there was a rush of wings, and a flock of mallards left the decoy. "There now, you ha' done it!" exclaimed the keeper, excitedly; "all them mallards were following the dog into the pipe, and we could ha' got a second lot." We expressed our sorrow in becoming terms, and watched the very expeditious way in which he extracted the birds from the tunnel net, wrung their necks, and flung them into a heap. Several of the poor things were not immediately killed, but tried to flutter away, and were brought back by the dog. We had got twenty-one birds, nineteen being teal and two mallards.

GEORGE CHRISTOPHER DAVIES

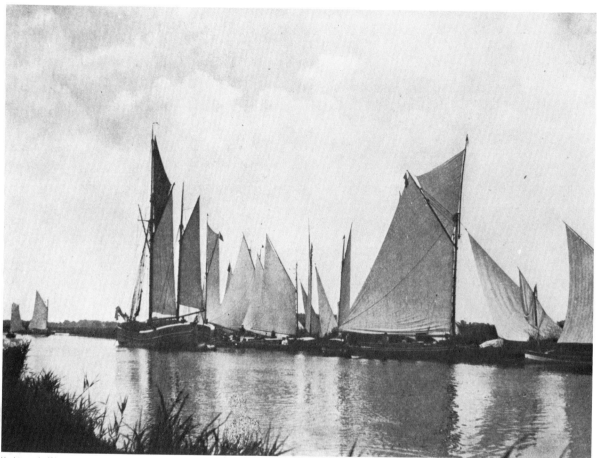

Yachts on the Waveney

George Christopher Davies from *The Scenery of the Broads and Rivers of Norfolk and Suffolk* 1885

It was a lovely evening, with an orange glow in the west which was reflected back from the tanned sails of the wherries as they came up from Yarmouth with the flood, and, brightest of all, from the yellower sails of a top-sail barge from Kent. She came along in stately grandeur, with her lee-boards up as the wind was fair.

GEORGE CHRISTOPHER DAVIES

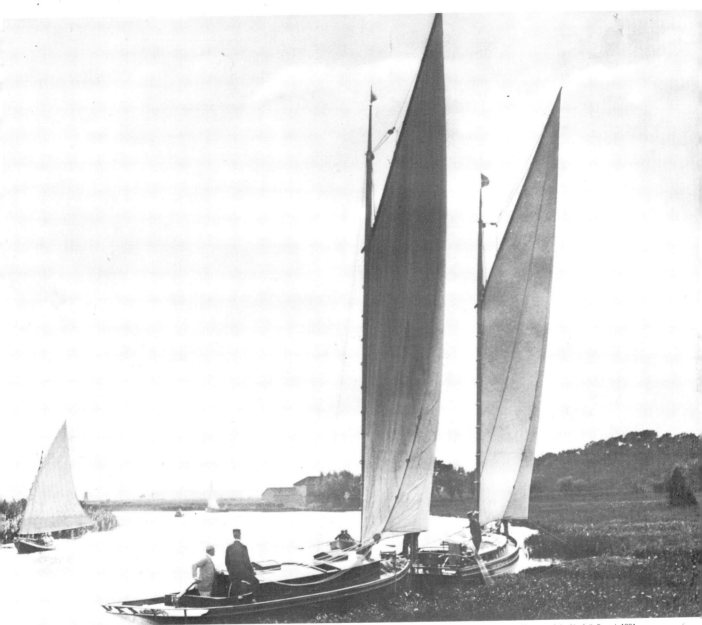

Racing Craft on the Waveney

J. Payne Jennings from *Sun Pictures of the Norfolk Broads* 1891

These yachts are in a somewhat difficult position for one to obtain a good idea of the enormous sail-area they can spread. Persons from other parts of England often marvel at the huge sails which these craft can carry, but it must be remembered that most of them have heavy leaden keels which make them very stable in the water. Beside this they are usually constructed to carry a centre-board which gives them still further stability. Breydon Water and Wroxham Broad are the chief places for yacht racing, while Oulton Broad also has its fair share for yachts up to ten tons.

E. R. SUFFLING

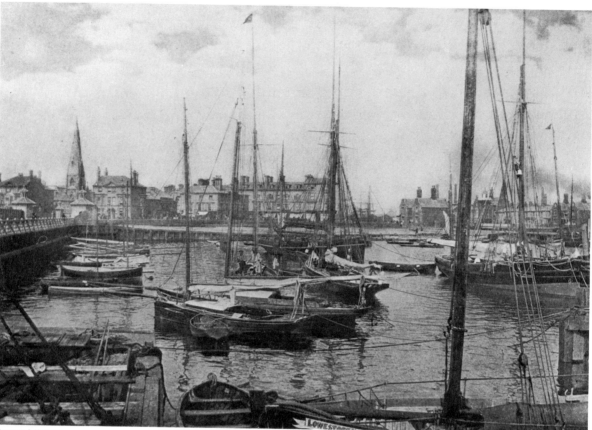

Lowestoft Harbour

George Christopher Davies from *The Scenery of the Broads and Rivers of Norfolk and Suffolk* 1885

The account of the admission of the salt sea to the freshwater Lake Lothing in 1831, as told by the Rev. Alfred Suckling in his *History of Suffolk*, is so interesting that it will bear quotation. He says:—

"On Friday the 3d June in that year, the engineer had made the necessary arrangements for the purpose of bringing vessels into the harbour . . . Some of the circumstances attending the junction of the salt and fresh waters in the first instance were remarkable. The salt water entered the lake with a strong under-current, the fresh water running out at the same time to the sea upon the surface. The fresh water of the lake was raised to the top by the eruption of the salt water beneath, and an immense quantity of yeast-like scum rose to the surface. The entire body of the water in the lake was elevated above its former level, and on putting a pole down, a strong under-current could be felt bearing it from the sea; and at a short distance from the lock next the lake, there was a perceptible and clearly defined line where the salt water and the fresh met, and upon this line salt water might have been taken up in one hand and fresh water in the other. Lake Lothing was thickly studded with the bodies of pike, carp, perch, bream, roach, and dace; multitudes were carried into the ocean, and strewn afterwards upon the beach, most of them having been bitten in two by the dogfish, which abound in the bay. It is a singular fact that a pike of 20 lb. in weight was taken up dead near the Mutford end of the lake, and on opening the stomach a herring was found in it entire. The waters of the lake exhibited the phosphorescent light peculiar to sea-water, on the second or third night of the opening."

GEORGE CHRISTOPHER DAVIES

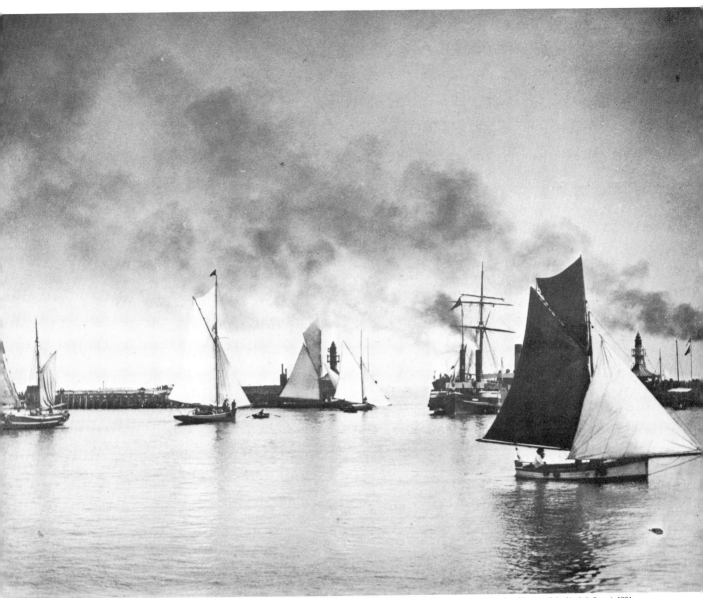

Yachts in Lowestoft Harbour

J. Payne Jennings from *Sun Pictures of the Norfolk Broads* 1891

This is one of the prettiest sights in Lowestoft, and one that visitors never tire of watching from the pier. Lowestoft Harbour is an illustration of what capital can do for a town. A person who has been from home for a few years would not recognize the present harbour, so much has it been enlarged and improved by the Great Eastern Railway Company. At no very distant date its trade bids fair to rival that of Yarmouth. In rough weather its harbour is not nearly so difficult to enter as that of Yarmouth, at the mouth of which a dangerous bar is frequently raised by adverse winds.

Lowestoft has a harbour specially set apart for yachts during the season, overlooking which is the smart-looking little building of the Yacht Club. Yachts can pass through Lowestoft Harbour into Lake Lothing, and so along to Oulton Broad (two miles) and the River Waveney.

E. R. SUFFLING

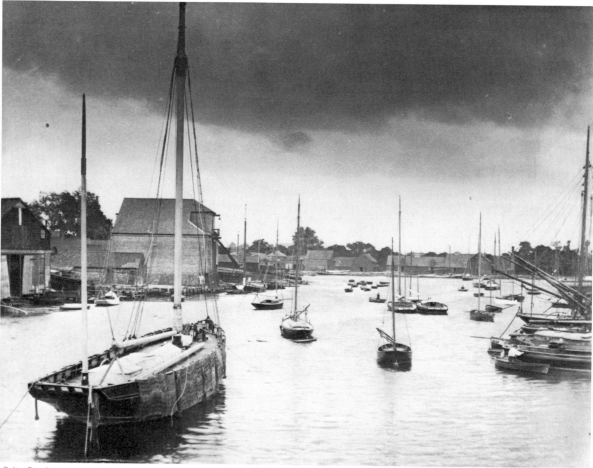

Oulton Broad

J. Payne Jennings from *Sun Pictures of the Norfolk Broads* 1891

The mode of tickling tench, which at one time was common enough on some of the Broads, is not generally known at Oulton; but one man is an adept at it. He has frequently taken up to 17 brace of tench, all large, in the course of a summer's afternoon. Watching where they bask on the surface in the hot sun, he would row gently up and note the short rushes of the disturbed fish into a bed of weeds, and then, approaching cautiously, he would take hold of the fish with his hands and lift it into the boat. The tench, so long as it does not see you, seems to think that the fingers gently creeping under its belly are only bits of weed, and it only wakes up when too late. Shallow weedy water and still hot days are essential for this work; and whether it is because the summers have for so long been cold and wet, or because the present generation have lost the art, it is certain that this singular mode of capture is not now so commonly practised as of yore.

GEORGE CHRISTOPHER DAVIES

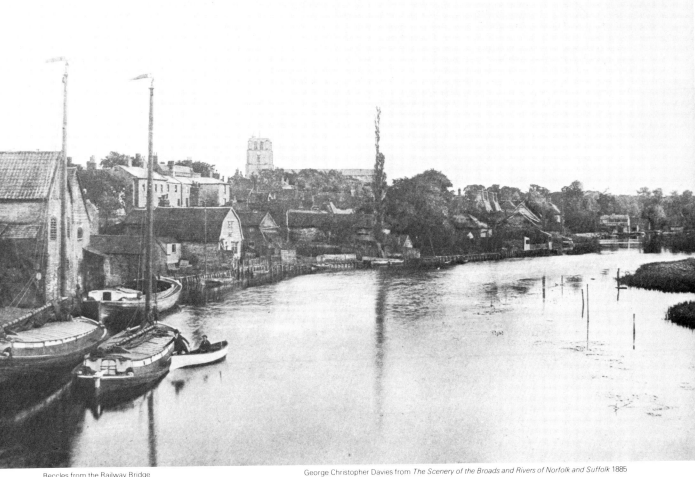

Beccles from the Railway Bridge

George Christopher Davies from *The Scenery of the Broads and Rivers of Norfolk and Suffolk* 1885

From the river, Beccles has a pretty appearance. It stands well on high ground and is dominated by a fine and massive church—a peculiarity of which is that its main tower stands apart from it.
We rowed up under the narrow stone bridge and landed below the church:
"There's a man with a concertina on sticks", quoth one urchin,
"No, it isn't. He's going to take the church's likeness", said another, more advanced in worldly knowledge.

GEORGE CHRISTOPHER DAVIES

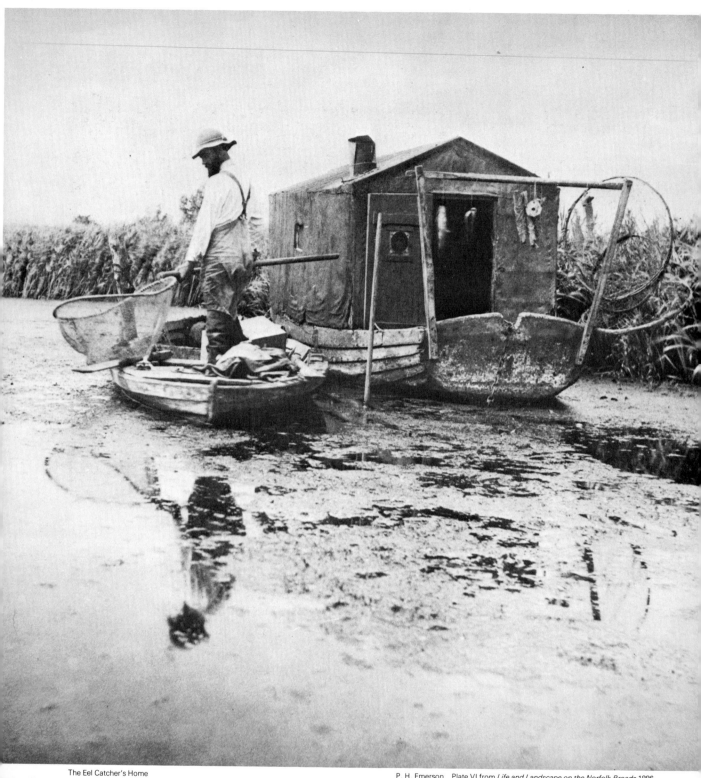

The Eel Catcher's Home

P. H. Emerson Plate VI from *Life and Landscape on the Norfolk Broads* 1886

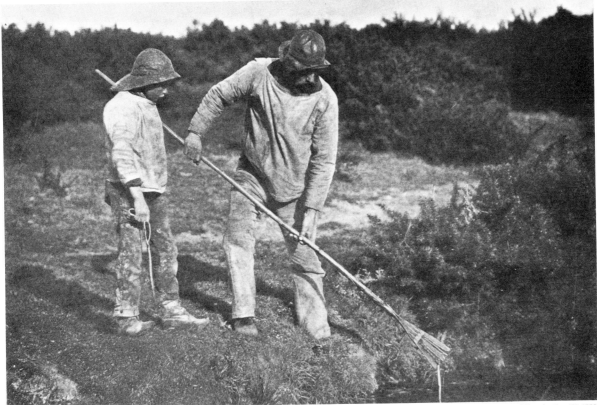

Eel picking in Suffolk waters

P. H. Emerson Plate XVII from *Pictures of East Anglian Life* 1888

The Eel Catchers

Babbing is often a profitable and easy way of catching eels. The *modus operandi* is to thread a number of lobworms on worsted until a bunch is formed; a weight is attached, and the bait is lowered to the bottom. The babber sits in his boat through the night, with a short rod in each hand, and every now and then lifts the bab a little. When he feels the tug of an eel, he lifts it gently into the boat, the eel's teeth being entangled in the worsted. The great time for babbing is when the roach and bream are "rouding" or spawning in the spring. There are certain well-known spawning-grounds, such as the gravelly shoals on the Ranworth bank of the Bure, opposite Horning Church, and lower down at St. Benedict's Abbey. On these grounds the fish collect to spawn in vast numbers, and the eels follow them in hosts. The babbers follow the eels, and you may see fifteen boats as close together as possible, babbing away, and catching as much as four stone-weight of eels per boat of a night.

Eel-spearing is quite an athletic occupation, as well as one requiring much skill and knowledge of the habits of eels. There are two kinds of spears in use in different parts of the Broad district. The one in use on the Yare and Bure is the "pick," formed of four broad serrated blades or tines, spread out like a fan; and the eels get wedged between these. The spear in use on the Ant and Thurne is the dart, and is made with a cross-piece, with barbed spikes set in it like the teeth of a rake. The mode of using both is the same. They are mounted at the end of a long slender pole or shaft, by which they can be thrust into the mud. These thrusts are not made at random; but the "pickers" watch for the bubbles which denote the presence of an eel in the mud, and they aim accordingly.

GEORGE CHRISTOPHER DAVIES

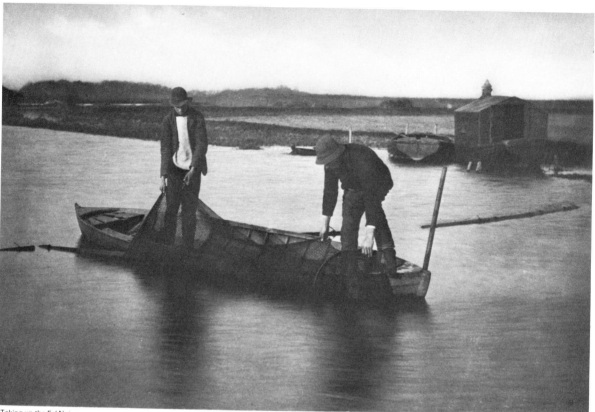

Taking up the Eel Net

P. H. Emerson Plate VII from *Life and Landscape on the Norfolk Broads* 1886

There are about a score of these nets set at various points on the rivers Bure, Thurne, Ant, and the dykes leading to the various Broads, and their use is of great antiquity. Some of them have been worked in the same spots for hundreds of years. The mode of setting them is as follows:—

A wall of close-meshed and stout network is stretched across the river, the lower side weighted with lead and resting on the bottom, and the upper side floated by means of pieces of wood. In the bed of the river are three stakes—one in the middle, and one near each bank; to each of these stakes blocks are attached; through these blocks pass separate ropes, one end of each rope being attached to the top of the net above each stake, the other ends of the ropes leading to the eel-boat moored by the bank. By hauling on these ropes the net can be pulled to the bottom of the river. In the wall of netting there are (say) four apertures, at equal distances apart; to each aperture a narrow network pipe or tube about six yards long, and kept distended by wooden hoops, is attached. At equal distances in the interior of each tube three funnel-shaped circles of net are fastened (the shape of these can be understood by reference to a bow-net, or to one of those ink-bottles out of which the ink cannot flow when turned upside-down). These "pods" are stretched down the river, and attached to stakes, fixed in the bed of the river, by ropes, which lead from buoys on the surface of the water, through blocks on the stakes, and fastened on shore, two on either side. The eels passing down the river make their way into the long "pods" through the narrow necks or apertures of the stops, and cannot find their way back again. The nets are only set during ebb-tide and at night. While they are set, the men must be constantly on the watch. On the approach of a wherry, the ropes are hauled upon so that the net is pulled down to admit of the wherry passing over.

GEORGE CHRISTOPHER DAVIES

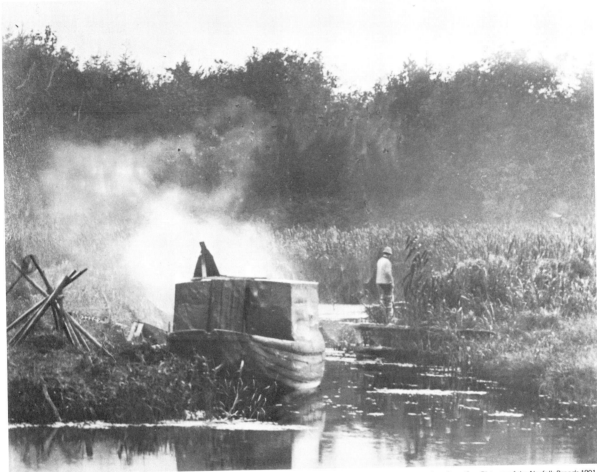

Eel fisher on the Bure

J. Payne Jennings from *Sun Pictures of the Norfolk Broads* 1891

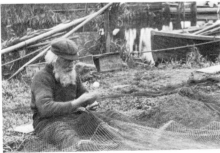

Eel Net Mending Unknown photographer

The wind was fair, as our course up the Bure lies north for a mile or two, and then due west as far as Acle: and it is well when it is fair, for the next twelve miles are very uninteresting. There is nothing whatever to see, except eel nets and boats.

These eel boats are precisely the Noah's ark of childhood, and are of ancient appearance; we have never seen a new one. The tanned nets, which are hung up to dry upon the stakes around the dyke in which the boat is moored, are carefully kept and well mended. Through the night the eel fisher sits in his cabin, like some great spider in his web, waiting for the eels the stream will bring to his net.

GEORGE CHRISTOPHER DAVIES

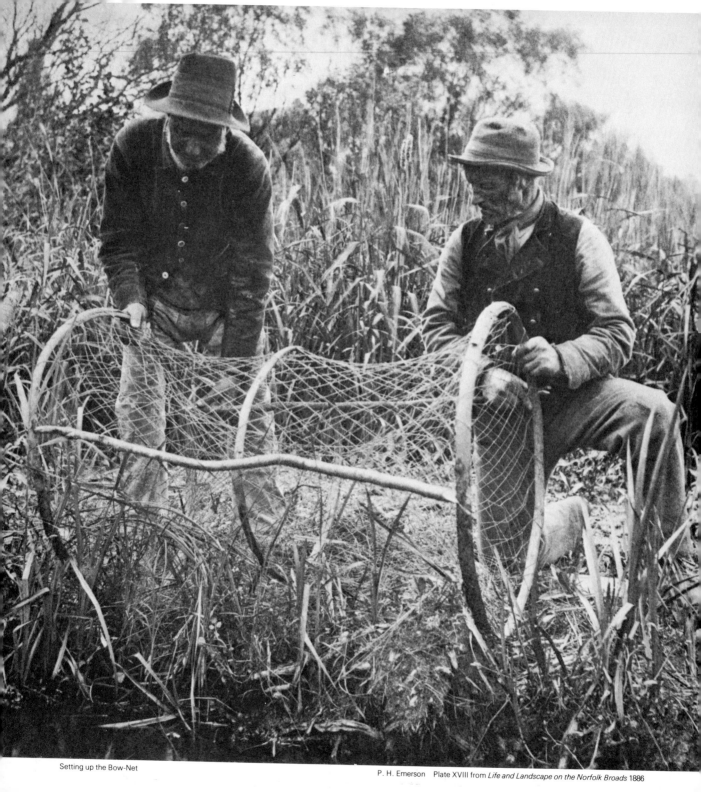

Setting up the Bow-Net

P. H. Emerson Plate XVIII from *Life and Landscape on the Norfolk Broads* 1886

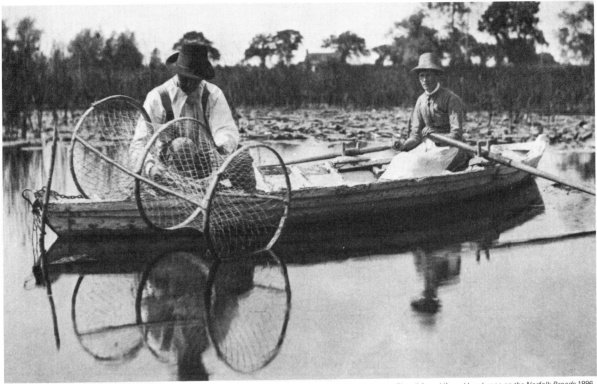

Setting the Bow-Net

P. H. Emerson Plate II from *Life and Landscape on the Norfolk Broads* 1886

The Bow-Net

Here we have an old Broadman and his daughter out in their flat-bottomed boat on a hot July afternoon, about to drop a bow-net into a likely corner of the Broad to catch some tench, that most edible of fish, firm and glutinous—the sole of the fresh waters.
The net, deftly braided by the girl's skilled fingers, has been bent by the old man to hoops of split hazel, and set taut by sticks of the same, notched at either end to fit the outer hoops, thus holding them wide apart, and forming a firm cylindrical cage. From each end springs a cone-shaped inner net which, tapering to the centre of the cage, has an opening at its apex; these openings are the entrances to the trap; a string fastened to the hoop at the opposite end holds each one in position. A very large fish can easily push its way into these openings, but a small one would have much difficulty in getting out again, even if it managed to find the hole. The old man is putting a stone in the net to keep it on the bottom.

T. F. GOODALL

A bow-net set just below the town of Beccles had sixteen brace of fine tench in it when taken up. The attraction in this case was a bright-coloured bunch of flowers fastened inside.

GEORGE CHRISTOPHER DAVIES

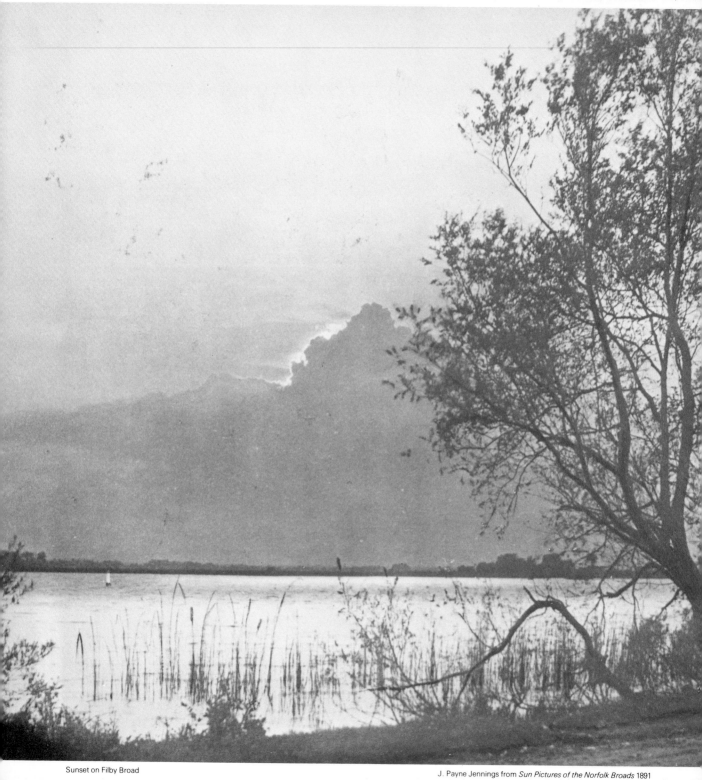

Sunset on Filby Broad

J. Payne Jennings from *Sun Pictures of the Norfolk Broads* 1891

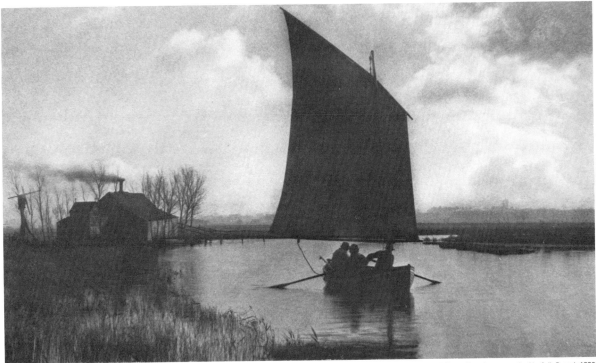

The Old Order and the New

P. H. Emerson Plate XII from *Life and Landscape on the Norfolk Broads* 1886

The Lower Bure

Many of the marshes around the group of Broads up the "north river", as the Bure is usually called, are left in their pristine wildness; but in the lower waters there is a very complete system of drainage. The river surface, as a rule, is much higher than the adjacent marshes which, as the moisture was pumped out of their peaty and spongy soil, shrank and sank just as a sponge does in drying, until they left the river level several feet above them. A low embankment on either side of the river confines its waters, and at the outlets of the drains are pumps which lift the water out of them into the river. These pumps were all formerly, and many still are, worked by means of small windmills; and it is a curious sight, on looking over the wide marshes to see the scores of windmills all twirling merrily around. Steam is now used at the outlets of the more important drains, and does the work more effectually. Even now the water often gains the mastery.

GEORGE CHRISTOPHER DAVIES

The Eel's-Foot Inn, Ormesby

J. Payne Jennings from *Sun Pictures of the Norfolk Broads* 1891

At last we came to the open water of Filby Broad, down which a stiff breeze was blowing, knocking up what to the little Berthon was a respectable sea. Rowing across Filby, we came to a little red-brick bridge, and passing under this, found ourselves on another and much larger Broad, which, by the map, appeared to be Rollesby. The main body of this lay to our left, and in conjunction with Ormesby Broad, reached for some three miles further. We made for a water-side hostelry, known by the curious name of the Eel's-Foot, which we found embowered in trees, and with inviting arbours in front, where we refreshed ourselves with strawberries and "shandy-gaff."

The fishing is free, at all events to persons going to the house named, and uncommonly good sport is to be had amongst pike, rudd, and bream, the number of a catch being counted by the hundred, and the weight by the stone. For fishing, pure and simple, Ormesby Broad is as good a place as any to visit.

GEORGE CHRISTOPHER DAVIES

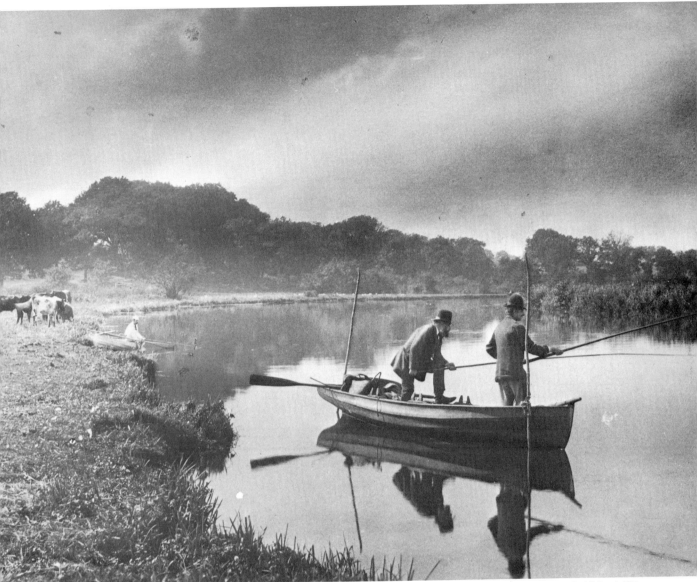

Angling on the Bure

J. Payne Jennings from *Sun Pictures of the Norfolk Broads* 1891

The Norwich artisans will walk from Norwich on the night before any holiday, hire a boat, row on to the Broad, moor their boats, throw in their ground bait, and then lie down and go to sleep, ready to commence fishing at the earliest dawn, when they will probably get two or three stone weight of bream by breakfast time. The bream is not a very toothsome fish to eat, but large quantities were formerly sold by the professional fishermen to the poorer Jews in our large towns for use on fast days, of course at a very cheap rate; and to the fishermen on the coast for use as bait.

GEORGE CHRISTOPHER DAVIES

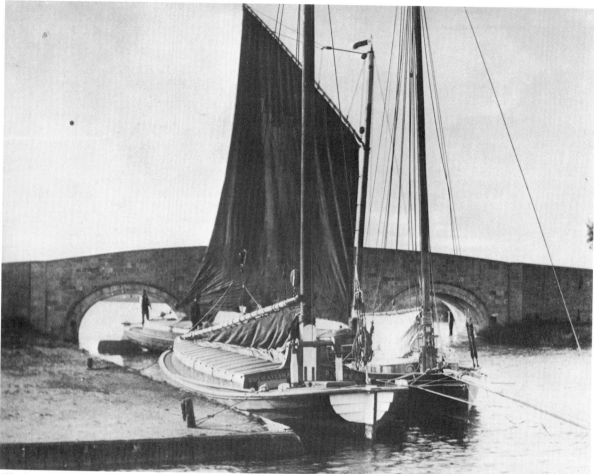

Wherries near Acle Bridge

J. Payne Jennings Unpublished *c.* 1880

The way the masts are lowered when shooting a bridge is startling. On you go before a strong breeze until within 100 yards of the bridge, when the sail is sheeted flat; the man goes leisurely forward, leaving his wife or son at the helm, lets the windlass run; down comes the sail; the gaff has then to be detached from the mast and laid on the top of the hatches; then, just as you think the mast must crash against the bridge, it falls gently back, and you shoot under; up it goes again without a pause, the forestay is made fast and under the pressure of the windlass the heavy sail rises aloft, all before you have quite got over your first impulse of alarm.

GEORGE CHRISTOPHER DAVIES

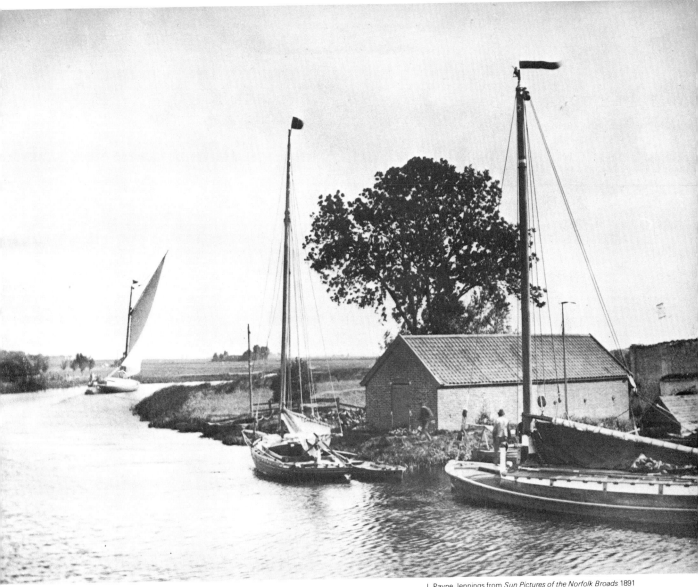

Express Wherry leaving Acle Bridge

J. Payne Jennings from *Sun Pictures of the Norfolk Broads* 1891

Before a strong breeze and with the tide, the wherries will attain a speed of 7 or 8 miles an hour, and even at that pace, create less disturbance of the water than a small yacht.
The sail is used without tanning until it gets dirty, when it is dressed with a mixture of seal-oil and tar, and so becomes of a rich dark-brown, which in the sunlight often gives the needed warmth of colour to the landscape.

GEORGE CHRISTOPHER DAVIES

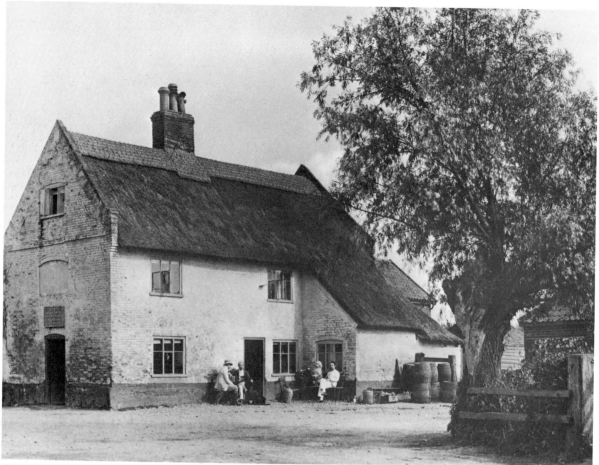

The Angel Inn, Acle Bridge

J. Payne Jennings Unpublished *c.* 1890

As we had to get a new quant from Yarmouth, we had to wait here until the morning, and amuse ourselves with fishing for bream, of which large quantities may be caught here, and of good weight. Acle is a capital fishing station, and is accessible from Norwich by the line to Yarmouth, branching off at Brundall. Acle is a charming village, and offers many residential facilities to those who are fond of country life and aquatic amusements. It is within easy reach of all the best Broads, lying on the rivers Bure and Thurne, and not far by water to Yarmouth. There are three good inns—the "King's Head," the "Queen's Head," and the "Angel." The most convenient is the one by Acle bridge (the "Angel"), kept by a landlord who well understands and can supply the needs of yachting men and anglers. There is staying accommodation at the inn, a wagonette to meet the trains, fishing boats to let, and every attention from the host. As there is good mooring to both banks, especially above the bridge, and the river is wide and deep, Acle is rapidly becoming a favourite yachting and angling station.

Owing to the wide breadth of marsh there is a true wind for sailing, and the reaches above Acle to Thurne mouth are wider and finer than any other parts of the Bure.

GEORGE CHRISTOPHER DAVIES

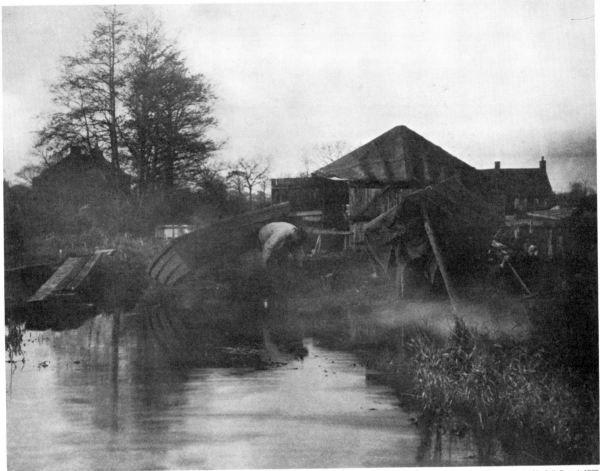

A Norfolk Boat-Yard

P. H. Emerson Plate XIII from *Life and Landscape on the Norfolk Broads* 1888

Country Boatyards

On the right hand side as we entered the Broad [Womack Water] was a bit of an old-world picture: a boat-builder's shed, large and old, and of picturesque construction, stands on the margin, amid low bushes and under the shade of mighty trees. Beneath it a large boat of an age and type unknown, and a wherry sleepily awaiting repair. Behind the boat-house a barn, whose high-thatched roof is shaded by the branches of a cherry-tree. By the side of the boat-shed is a dyke, where sundry small craft are ensconced. Behind all, and peeping out of a garden run wild, are low, thatched cottages, and scattered about among the tall grasses, are trunks of trees, curved "knees" of oak, suitable for boat-building, and broken up boats and punts. On the still water in front is moored a floating eel-fisher's hut, and all around is the sense of the repose of the past. The former busy life has left its emblems resting in acquiescence with the fate which contracts the sphere of their usefulness, day by day, and year by year, as the vegetation slowly, but surely, drives out the water.

GEORGE CHRISTOPHER DAVIES

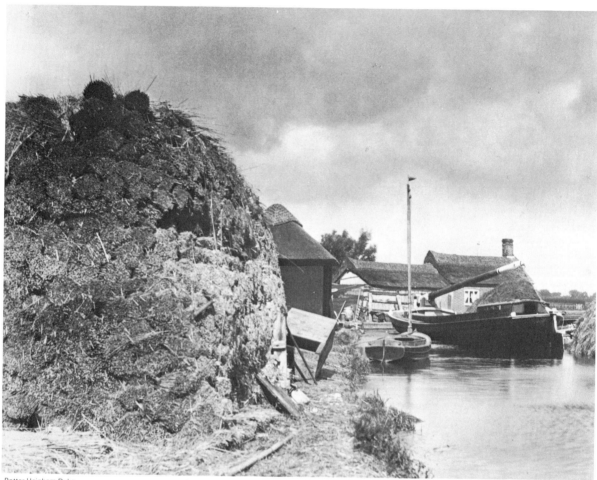

Potter Heigham Dyke

J. Payne Jennings from *Sun Pictures of the Norfolk Broads* 1891

The Thurne

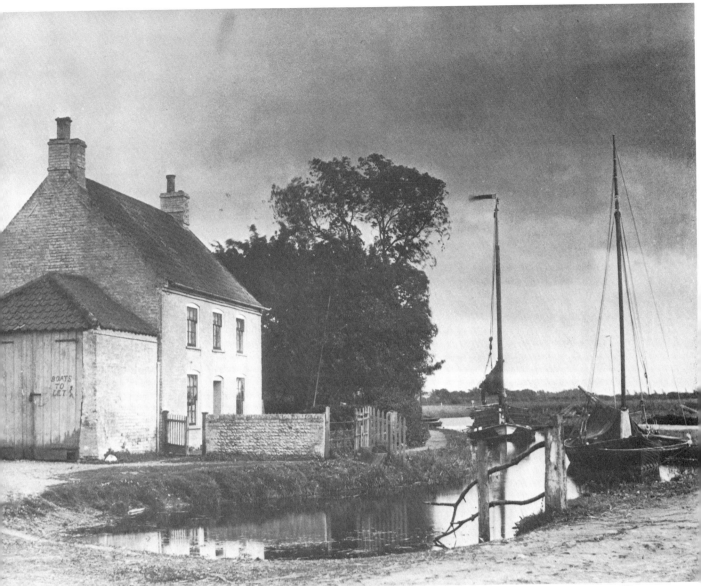

The Pleasure Boat Inn, Hickling Staithe

J. Payne Jennings Unpublished *c.* 1890

The "Pleasure Boat" Inn, Hickling Staithe is kept by Host Bowles, who has numerous sailing and rowing boats at his disposal for letting to visitors. Finding the numbers of persons anxious to secure his rooms increasing rapidly he has had additions made to the house, which is now double the size of that shown in the photograph. As there is no other inn adjoining the Broad he has virtually a monopoly of the visitors, but they are quite safe in his hands, for he treats them very fairly.

The nearest station is Catfield, about two miles distant. The village, a very large and straggling one, is three-quarters of a mile away. The Church lies still farther off, probably one and a quarter miles.

Visitors need not look for the ruins of Hickling Priory, for they are so meagre as not to be worth the walk of two miles each way to visit them.

E. R. SUFFLING

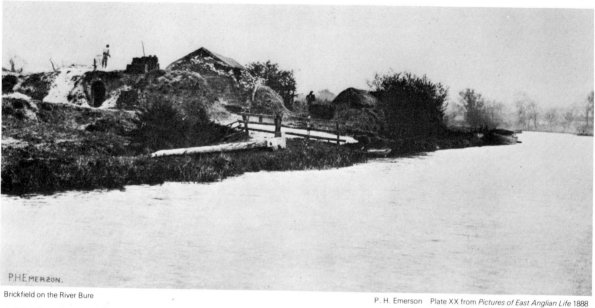

Brickfield on the River Bure

P. H. Emerson Plate XX from *Pictures of East Anglian Life* 1888

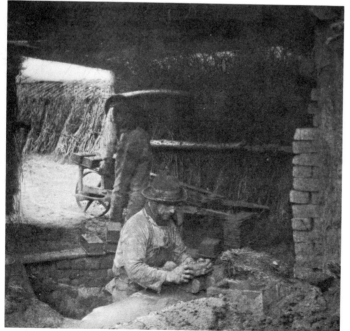

Brickmaking

P. H. Emerson Plate XXII *ibid*

Brickmaking

When rowing, one lovely spring morning, on a Norfolk river, we passed one of those picturesque brickyards not uncommon in that delightful county.

The heap of clay comes from the clay-mill, and is roughly worked with spade and water afterwards by the brickmaker. He takes a lump of clay and fills the moulds whose internal measurements are the exact size of a brick until it is quite full, then with the slice he shaves off all the clay projecting over the mould and so forms a flat surface, while the counter forms the other. He dusts it lightly with clay and puts it on one of the barrows. The boy waits until the regulation load of twenty is ready, when he wheels it off to the shambles, where it remains for nine days and nights if the weather be dry.

An average workman can make fifteen hundred bricks a day . . . these men suffer much from rheumatism.

P. H. EMERSON

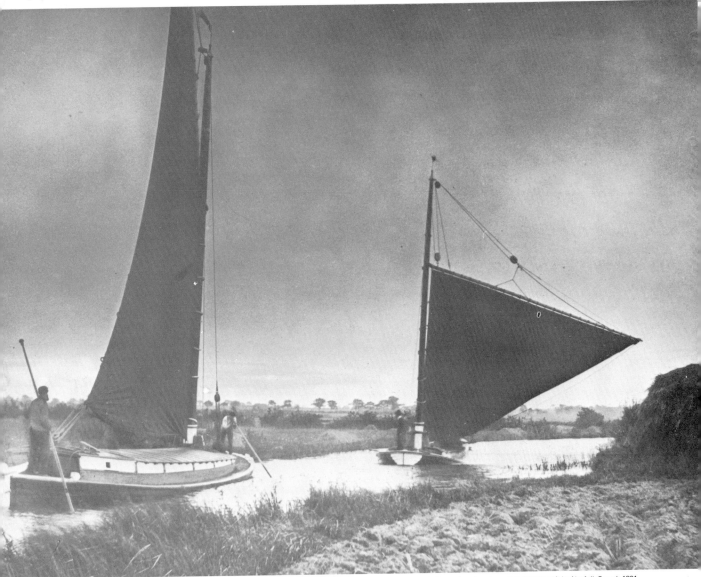

Wherries passing on the Ant

J. Payne Jennings from *Sun Pictures of the Norfolk Broads* 1891

The Ant

The Ant is a tortuous stream, having its source in the Antingham Ponds, and, after a course of some eighteen miles, empties its waters into the River Bure, near St. Benet's Abbey. It is in places so narrow that when two wherries meet there is nothing to spare, so that care has to be taken to prevent any mishap to sails or gear. The usual rule is the same as on most rivers, viz., "that the vessel with a free wind gives way to the one beating up."

E. R. SUFFLING

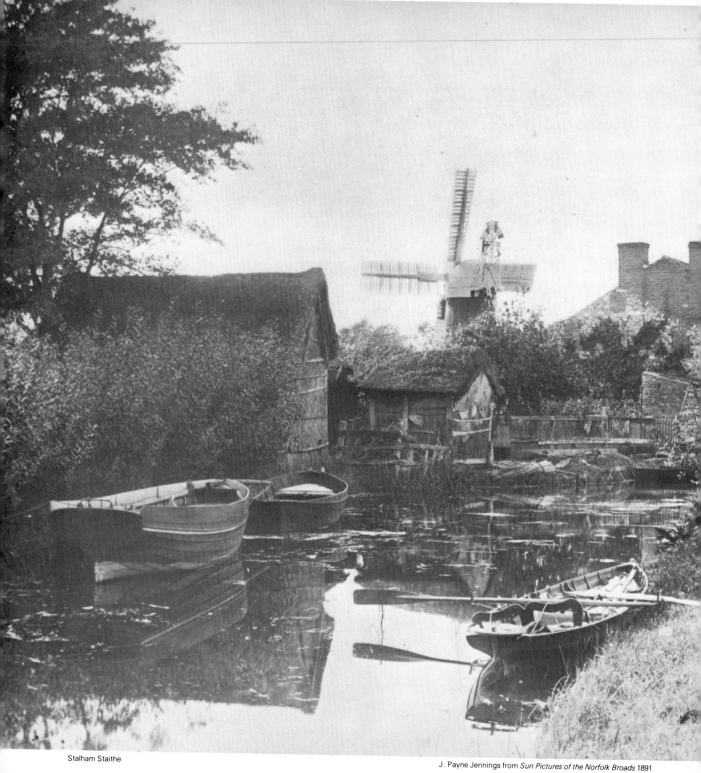

Stalham Staithe

J. Payne Jennings from *Sun Pictures of the Norfolk Broads* 1891

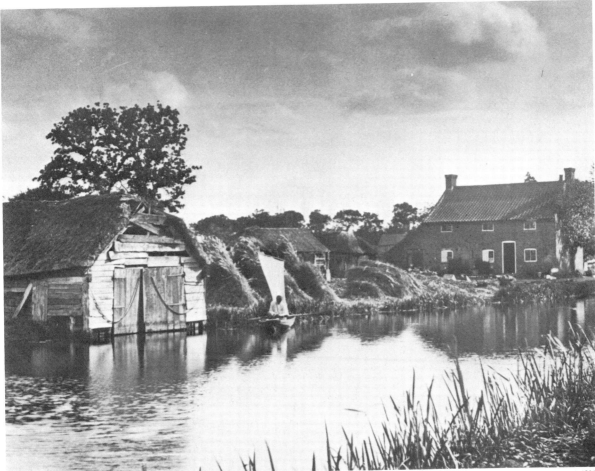

Gay's Staithe, Barton Broad

J. Payne Jennings from *Sun Pictures of the Norfolk Broads* 1891

Reed-stacks at Barton

George Christopher Davies from *The Scenery of the Broads and Rivers of Norfolk and Suffolk* 1885

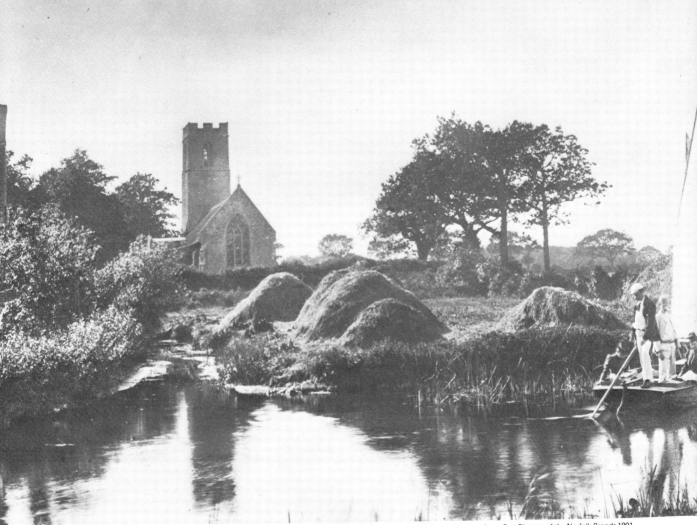

Irstead Church on the Ant

J. Payne Jennings from *Sun Pictures of the Norfolk Broads* 1891

The Ant is just like a canal, except that it has no towpath. The fishing in it is remarkably good, particularly at Irstead shoals, where there is a stretch of water about half a mile long, with an even depth of four to five feet, and a firm, level, pebbly bottom, a curiosity in this land of boggy streams. This is an excellent spot for perch and pike. It is marked by the presence of a church on the western bank, and is one of the few places on these waters where a person who cannot swim can bathe with safety or comfort. The muddy bottom, of course, prohibits wading. As you approach the entrance to Barton Broad, the bottom becomes muddy again, and the Broad itself is full of mud; there being large "hills" where the water is not more than two feet deep. The navigable channels wind between these hills, and are marked out by posts. The Broad is a mile long, and very pretty, and the entrance to it is four and a half miles from the mouth of the Ant. In our light-draught lateener, we ignored the channels, and sped about all over, often, however, finding our speed diminished, as the keel cut through the soft mud, and turned up yellow volumes of mud behind. It is a curious fact that in some Broads and portions of Broads, the mud is of a light yellow colour, and in other portions black. As all this mud is the result of decayed vegetation, this difference is singular.

GEORGE CHRISTOPHER DAVIES

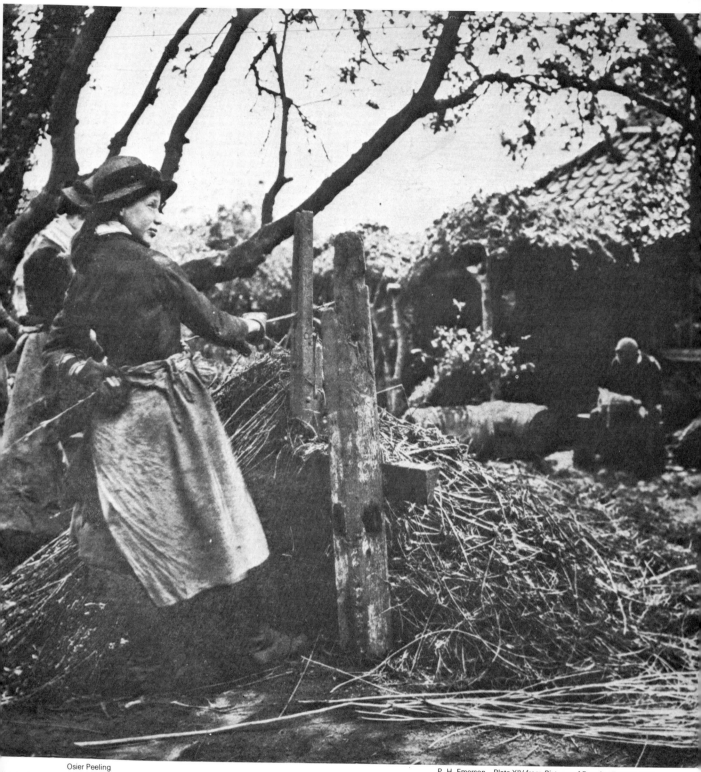

Osier Peeling

P. H. Emerson Plate XIV from *Pictures of East Anglian Life* 1888

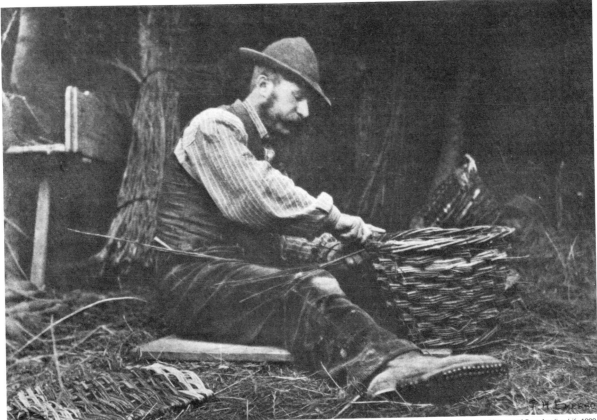

The Basket-Maker

P. H. Emerson Plate XV from *Pictures of East Anglian Life* 1888

Norfolk Willow

The basket-maker buys the osiers from the farmer for five or six shillings a bunch, or two-and-sixpence to three shillings a bundle, including cartage. When they arrive at the basket-maker's, they are put in a dyke containing a little water, and here they weather, the object of which is to loosen the peel, which facilitates the peeling. We have seen the dyke full of bunches and bundles all sprouting, many with full-grown leaves, looking like osier-plantations growing in very close quarters. They remain in this bath from April to June. If, however, they are intended for rough use, they never go to the dyke at all, for they are not peeled, but laid out in the sun to dry and 'brown', and the two kinds are always distinguished as 'whites' and 'browns'. To return to the whites, which are used for better wares. After soaking and growing in the dyke, the bundles are taken out, the lashing cut, and the muddy ends of the osiers washed in a large tub of water standing ready. Then they are carried to the brakes. These are uprights with a narrow slit, at the bottom of which is placed a sharp knife-edge. The operation of peeling is done by placing a single osier rod in the slit, and pulling it quickly and firmly through, the peel falling on one side, the white rod being placed on the operator's right. The peelers get threepence a bundle for their work, and can peel four bundles a day. We have always seen this work done by women and girls, for though requiring steadiness, not much strength is necessary. The old peelings are kept to protect bundles of 'browns' which have 'weathered' and are ready for the basket-maker. The whites are carefully put into sheds until required.

P. H. EMERSON

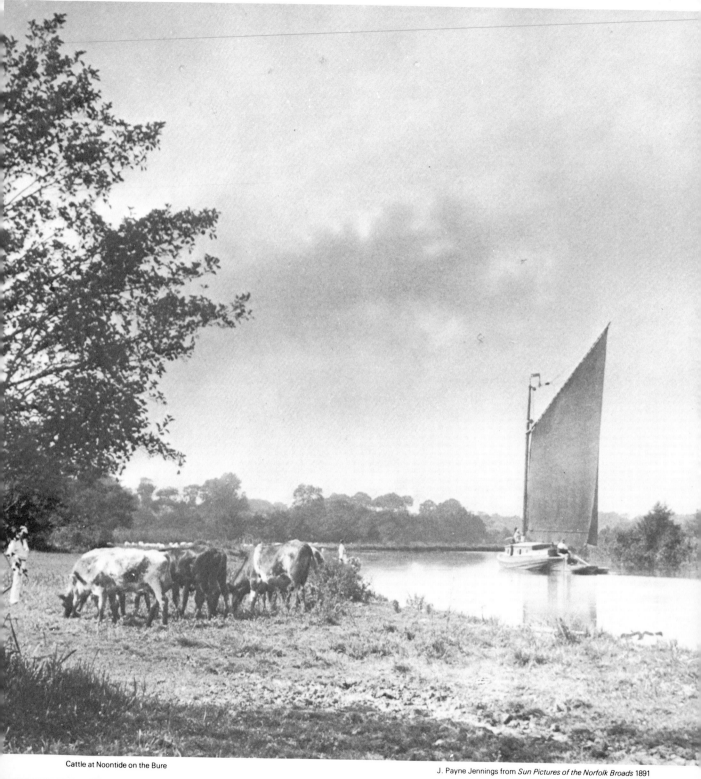

Cattle at Noontide on the Bure

J. Payne Jennings from *Sun Pictures of the Norfolk Broads* 1891

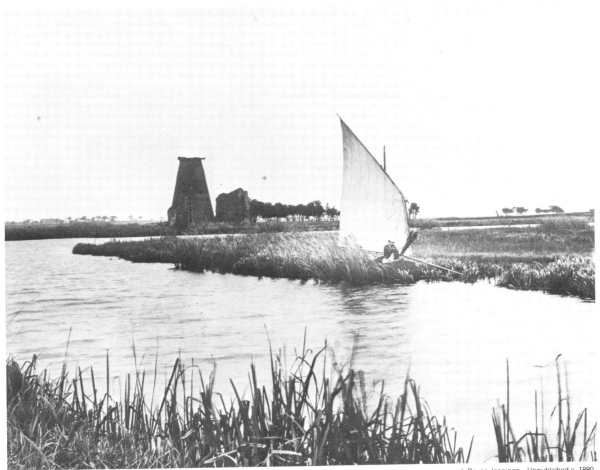

St. Benet's Abbey at Holme, Horning

J. Payne Jennings Unpublished *c.* 1880

The Upper Bure

St. Benet's Abbey. The Abbey of St. Benet-et-Holme was built in the year 1020, by order of King Canute, on the site of a hermitage which had been destroyed some time previously by the Danes, who massacred the brethren in cold blood.

The Abbey was in the occupancy of the Benedictine or Black Monks as they were called (from the color of their dresses), and it is alleged that they, with the help of the surrounding peasantry, offered a stubborn resistance to the forces of the Conqueror, which were sent to bring them to submission.

The Abbey walls may still be traced in places; they embrace an area of thirty-eight acres. The body of a brick windmill, built about 1740, still rears its huge bulk through and above the fine Gothic gateway.

E. R. SUFFLING

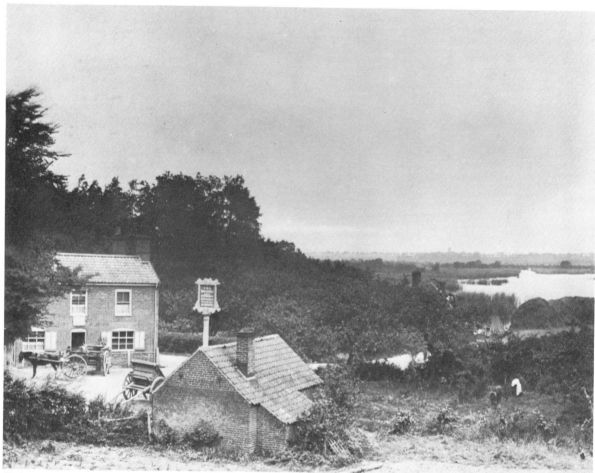

The Maltsters Inn and Ranworth Broad

J. Payne Jennings from *Sun Pictures of the Norfolk Broads* 1891

This inn lies so close to Malthouse Broad Staithe, that visitors may sail almost up to its door. It is noticeable for nothing in particular, except that one may obtain here a glass of the sweet ale for which Norfolk is famous. A blend of London bitter ale with the Norwich ale is much in vogue among visitors. "A quart of sweet and bitter" sounds strange at first, but it appears to be a welcome sound to many thirsty visitors in hot weather.

E. R. SUFFLING

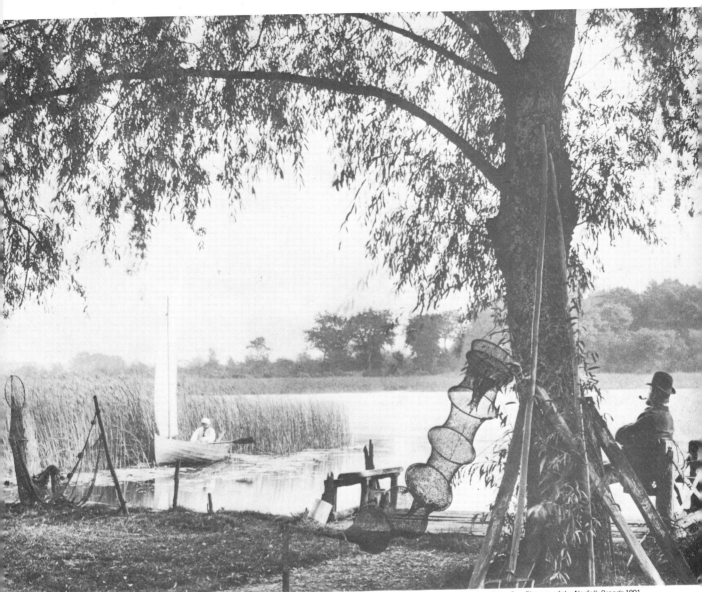

South Walsham Broad – The Landing Stage

J. Payne Jennings from *Sun Pictures of the Norfolk Broads* 1891

The curious arrangement of hoops and net hung from the tree is the poke-end of an eel net hung up to dry. Notice the return pieces in the interior of the net, in form of funnels; these prevent the eels from finding their way out when once in.
How many persons are aware that eels have scales? Very few, I believe. Their scales are covered by an outer skin, just as the coat of mail was worn under the tabard by the knights of old. It is a curious and interesting sight to see the tiny eels swim into their mother's mouth when alarmed.

E. R. SUFFLING

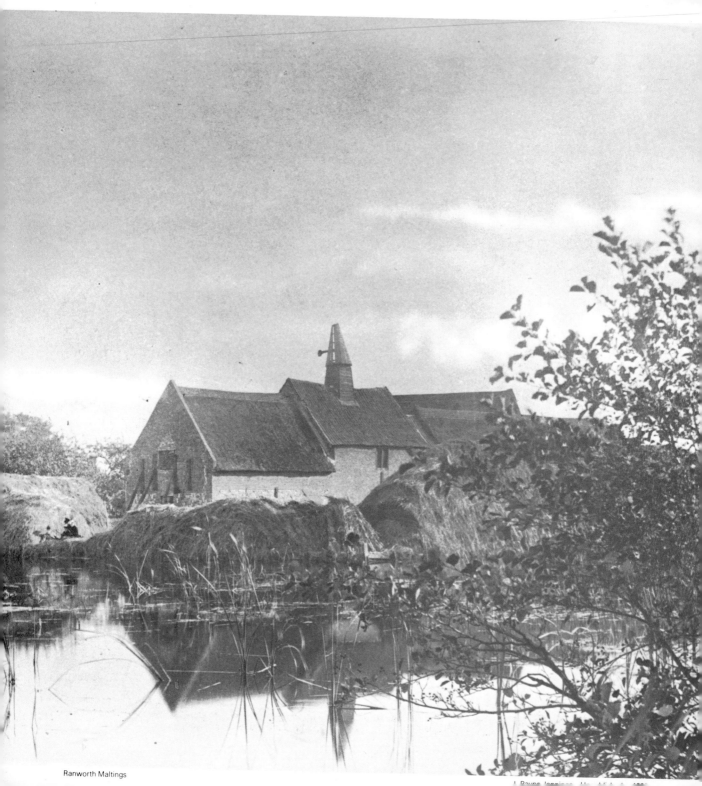

Ranworth Maltings

Ranworth Village near the Maltsters Inn

J. Payne Jennings from *Sun Pictures of the Norfolk Broads* 1891

Ranworth is a pretty, rustic village, with nothing whatever of the modern about it, either in architecture, aspect, or manners. All are rural, quaint, quiet, and decorous. The glory of the village is the church, perched upon an eminence above the village and Broad, while the glory of the church is its fifteenth century painted screen.

E. R. SUFFLING

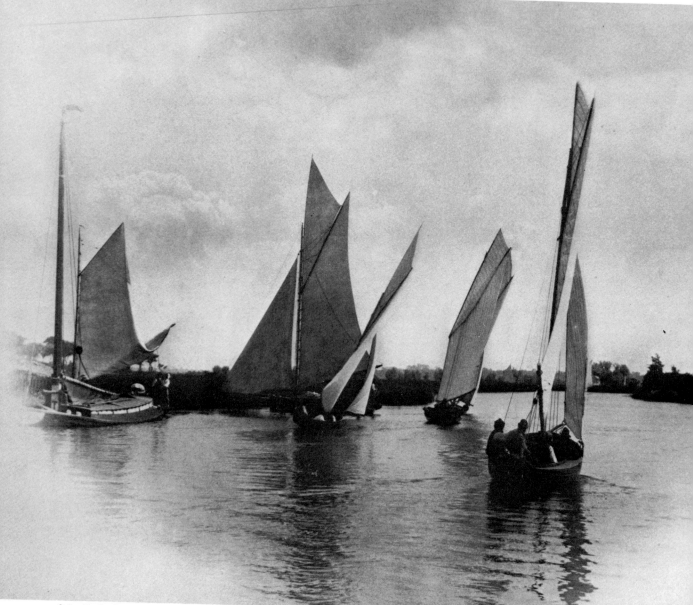

Sailing Match at Horning, 1885

P. H. Emerson Plate IV from *Life and Landscape on the Norfolk Broads* 1886

Nowhere is small boat sailing better understood than on the Norfolk waters. Many of the dykes and channels are so narrow that working a craft to windward through them approaches a fine art, only to be acquired by long practice and the closest attention. Various is the rig and many are the forms of vessel to be met with, from the smart five or ten ton cabined cutter, with long bowsprit and enormous jib, to the tiny heeled jolly-boat, with its balanced lug-sail. For a month past the landlord of the waterside inn, with an eye to business and sport combined, has industriously collected small sums, artfully drawing the attention of every likely customer to the subscription list hanging in his bar, till the total is large enough to provide prizes for his water frolic. Due notice of the match has been given by printed bills, with full particulars as to length of boats, time allowances, rig and other matters.

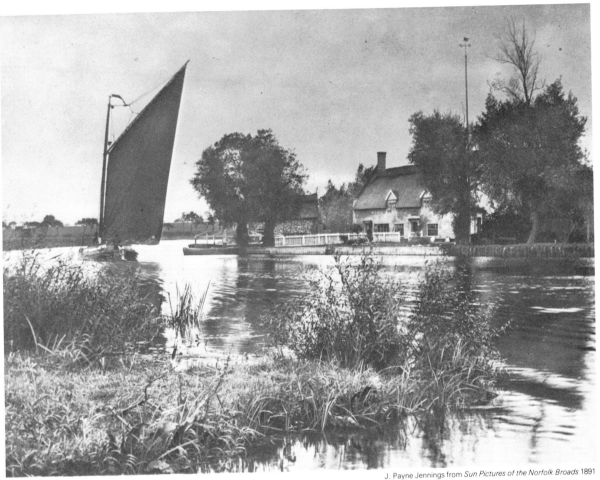

Horning Ferry Inn

J. Payne Jennings from *Sun Pictures of the Norfolk Broads* 1891

Spectators gather on the banks and throng the space in front of the oldfashioned inn, close by which the proprietor of a circle of 'steam horses' is plying his giddy trade. Swings are there too, and a shooting gallery in charge of his wife and daughters, while the sons invite the youthful rustics to bowl at a row of 'milky' coconuts.

All the crews being ready, the signal to start is given with an old fowling gun; jibs are pulled a-weather, main sheets eased off, and with helms up the heads pay off from the bank, the sails fill, and the boats skim swiftly down the river on the ebbtide towards the buoy with a red flag stuck in it, round which they have to turn.

The sailing matches over, a short race is contested in rowing craft of local types—dinghys, gun points, and flat-bottomed reed boats —the energy of the scullers being far more conspicuous than their training. A swimming match and a mirth-moving duck hunt conclude the sports on the river, after which the inn is besieged by a thirsty throng. With jugs of frothing ale the revellers squeeze into the taproom, some to argue, some to dance hornpipes to the never changing tune supplied by a squeaking fiddle. Much drinking and some fighting ends the day.

T. F. GOODALL

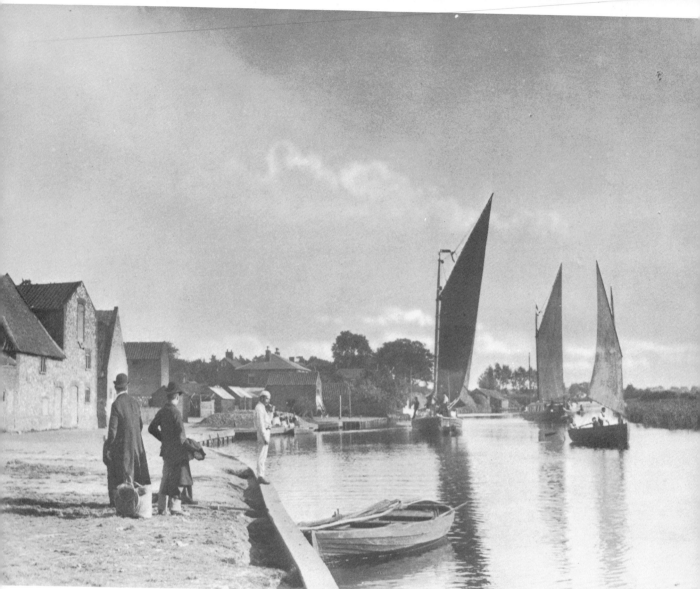

Horning Quay by the River Bure

J. Payne Jennings from *Sun Pictures of the Norfolk Broads* 1891

As we passed Horning village the children greeted us with a song, with which the children of Horning have greeted every passing yacht for generations:—

"Ho, John Barleycorn! Ho, John Barleycorn! Ho, John Barleycorn!"

The motive of the song is of course coppers. Its origin is unknown but even the three-year-old toddlers join in, and the general effect is pleasing.

GEORGE CHRISTOPHER DAVIES

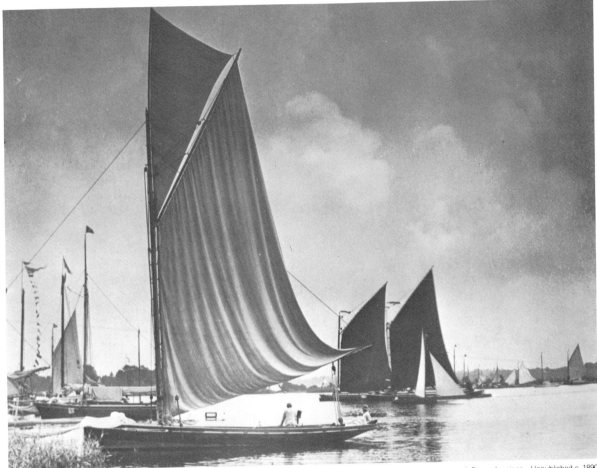

Wroxham Broad

J. Payne Jennings Unpublished *c.* 1890

Once a-year at least people go to Wroxham, on the occasion of the great annual picnic known as Wroxham Regatta; but every day and all day long the Broad has many visitors, for its beauty is great, and it is but seven miles from Norwich. Boating-men, fishermen, and pleasure-seekers generally enliven its broad bosom. Well does it deserve its popularity.

GEORGE CHRISTOPHER DAVIES

The First Frost

P. H. Emerson from *Life and Landscape on the Norfolk Broads* 1886

If the rivers are 'laid'—that is, icebound—their usual avocation ceases, many take to ice-gathering for the warehouses which supply ice for the carriage of fish, and at any symptom of a frost men will lay out with their wherries and collect the ice off the dykes, which of course freeze before the rivers, and a wherry may sometimes earn £30 or £40 in a winter. One of the ice warehouses is at the lower end of Oulton Broad; and on many a hot summer's day you may see the ice pouring in a glittering cataract down a timber-shoot into a vessel beneath.

GEORGE CHRISTOPHER DAVIES

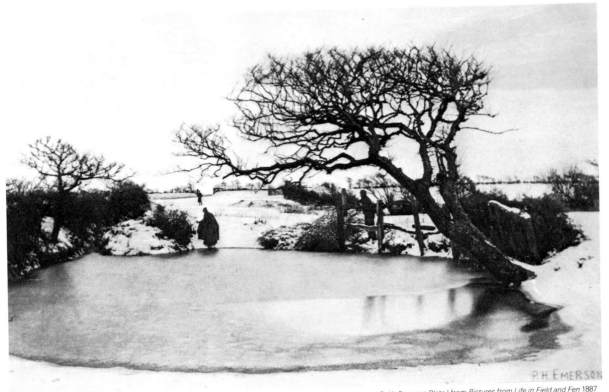

P. H. Emerson Plate I from *Pictures from Life in Field and Fen* 1887

A Winter's Morning

During the day several skating-parties came down by river, skating all the way from the bridge. They took the precaution of carrying coils of rope with them, in case of accidents, for there are always places in rivers where the water does not freeze so readily as in others.

One day in the following winter will ever be remembered. A thaw had taken all the snow away, and a subsequent frost had made the ice safe again. Then came a day of perfect beauty, bright and sunny, and mild as an ideal spring day. On that day the skating on Wroxham was simply marvellous. The ice was so clear and smooth it was difficult to believe that there was any ice at all covering the water; and the reflections of the marginal trees, and of the few cloudlets in the blue sky above, were very striking. The moisture of the surface, induced by the thaw, was no disadvantage unless you fell down; and with so much elbow-room and such capital ice, you might rush about to your heart's content. Figure-skating was at a discount with such a space to invite to speed. Then you could see the fish and weeds below you, and there seemed so little solidity in your support that it was easy to imagine that you were flying through mid-air.

On some of the shallower and smaller Broads people amused themselves by chasing the pike, which were easily visible under the ice, until they fairly run down and turned belly-up with fatigue, when a heavy blow on the ice with a stick would stun them until a hole could be cut to get at them.

GEORGE CHRISTOPHER DAVIES

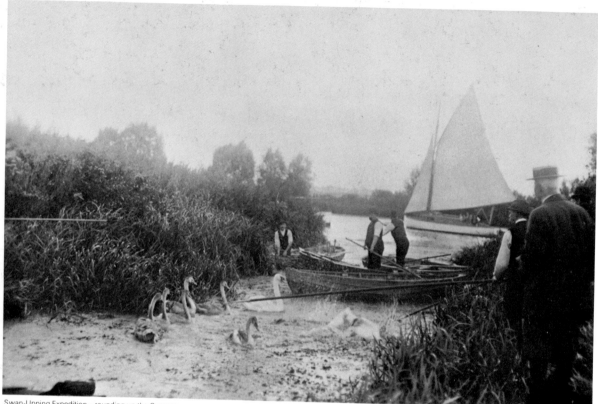

Swan-Upping Expedition – rounding up the Cygnets

Charles Aldous of Norwich *c.* 1916

Swan-Upping

In the summer, when the cygnets are sufficiently grown, the swan-upping takes place, when the cygnets are taken up and marked. The birds are remorselessly chevied by men in boats until they are secured, and tied together. Careful note is taken of the marks on the bills of the parent birds; and if, as is probable, they belong to different owners, the brood of cygnets is equally divided: if there is an odd one, it is tossed for.

GEORGE CHRISTOPHER DAVIES

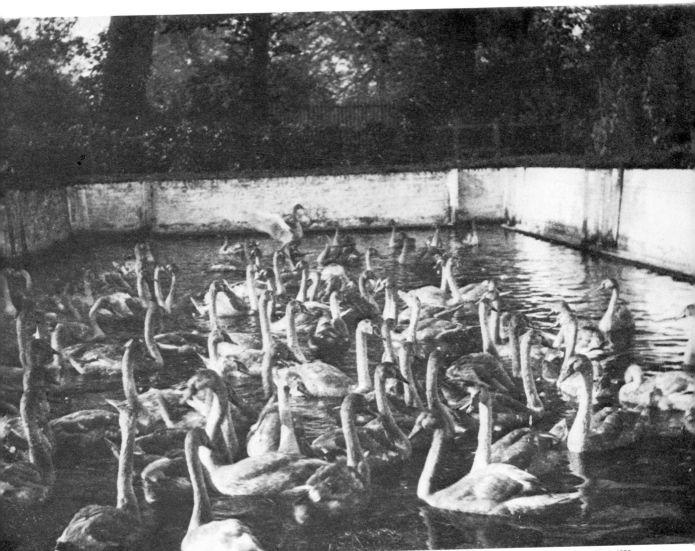

The Swan Pit

George Christopher Davies from *Norfolk Broads and Rivers* 1883

The cygnets taken up on the Yare are removed to a very curious place, which is well worth a visit. This is the swan-pit, at the back of the Old Man's Hospital, St Helen's, Norwich. This pit is an oblong pool or tank, about 40 yards long by 15 broad, with perpendicular sides. The water is connected with the river, and rises and falls with the tide. In this pool you will see, in the autumn, some seventy cygnets, and a most interesting sight it is. Here they are fattened for the table, or reared for transmission to their future homes. Around three sides of the pool are floating troughs, into which barley is poured down a long pipe with a funnel top. In addition to the barley, they are supplied with cut grass, of which they are very fond; and if you throw a handful in the water at one end, they will race eagerly towards it. They crowd up to the troughs at feeding-time, and their long necks twist in and out, and get entangled into such queer knots that you fear they will choke themselves.

As a rule, they live peaceably together; but if one bird is ill or weakly, the others attack it at every opportunity, —thus evincing that singular instinct which leads wild creatures to destroy the weak ones among them.

GEORGE CHRISTOPHER DAVIES

Select Bibliography:

John Payne Jennings

Photographs of Norfolk Broads and Rivers 1890
12 Albumin prints

Sun Pictures of the Norfolk Broads 1st Ed.
100 autogravures
2nd Ed. (with E. R. Suffling)
100 autogravures
3rd Ed. 100 ½ tones

Peter Henry Emerson

Life and Landscape on the Norfolk Broads (with T. F. Goodall) 1886
40 platinotypes

Idyls of the Norfolk Broads 1886
12 autogravures

Pictures from Life in Field and Fen 1887. 20 photogravures

Pictures of East Anglian Life 1888.
32 photo-etchings

Wild Life on a Tidal Water (with T. F. Goodall) 1890.
31 photo-etchings.

On English Lagoons 1893
15 photo-etchings

George Christopher Davies

The Swan and her crew 1876

Norfolk Broads and Rivers 1883
12 autogravures (1st Ed. only)

The Scenery of the Broads and Rivers of Norfolk and Suffolk Volume One
24 photo-engravings
Volume Two 24 photo-engravings